From Caspar David Friedrich to Gerhard Richter

German Paintings from Dresden

The J. Paul Getty Museum
Los Angeles

Galerie Neue Meister
Staatliche Kunstsammlungen
Dresden

From Caspar David Friedrich to Gerhard Richter

German Paintings from Dresden

Ulrich Bischoff

Elisabeth Hipp

Jeanne Anne Nugent

With contributions by

Heike Biedermann

Birgit Dalbajewa

Dietmar Elger

Gerd Spitzer

And an interview with

Gerhard Richter *by*

Jeanne Anne Nugent

Volume Editors

Jon L. Seydl *and* Anna Greve

Contents

MICHAEL BRAND

5 Director's Foreword

MARTIN ROTH

6 Foreword

ULRICH BISCHOFF & JON L. SEYDL

8 Acknowledgments

ULRICH BISCHOFF

11 The History of the Galerie Neue Meister

ELISABETH HIPP

15 Paintings from the Galerie Neue Meister at the J. Paul Getty Museum

33 **Paintings from the Galerie Neue Meister**
Caspar David Friedrich, Julius Schnorr von Carolsfeld,
Carl Blechen, Christian Friedrich Gille, Carl Gustav Carus,
Johan Christian Dahl, Ludwig Richter, Wilhelm Leibl,
Arnold Böcklin, Lovis Corinth, Max Liebermann, Otto Dix,
Karl Schmidt-Rottluff, Werner Tübke, and Gerhard Richter

JEANNE ANNE NUGENT

79 Overcoming Ideology: Gerhard Richter in Dresden, the Early Years

JEANNE ANNE NUGENT

95 Gerhard Richter's "Woodlands" and Other Things of the Past

100 **Gerhard Richter's *Wald* Series**

JEANNE ANNE NUGENT

113 Interview with Gerhard Richter

118 Bibliography
119 Lenders
119 Photo Credits
120 Colophon

Director's Foreword

One of the most exciting developments at the J. Paul Getty Museum in recent years has been the Museum's partnership with the Staatliche Kunstsammlungen Dresden. This cooperative venture is part of a series of collaborations with the Dresden State Museums, involving all the programs of the J. Paul Getty Trust. Previous collaborations between the Getty Museum and the Dresden museums include our Paintings Conservation studio assisting in the restoration of paintings from the Gemäldegalerie, the occasional integration of selected masterworks from Dresden within our galleries, and the 2001 exhibition of Meissen porcelain animals at the Getty. However, the present project is the first in a series of collaborative exhibitions forged by individual curatorial departments in both cities, working together to present works of art from Dresden to our audience in Los Angeles in meaningful and innovative ways that help reinterpret the collections of both of our institutions.

This exhibition takes as its point of departure the remarkable collections of the Galerie Neue Meister, one of great repositories of German painting from the 19th century to the present. The first part of the exhibition takes eight masterworks by the key figure of German Romantic painting, Caspar David Friedrich (1774–1840) and places them in dialogue with a series of recent abstractions by the city's other great painter, Gerhard Richter (b. 1932). This juxtaposition over a space of nearly two centuries brings into focus ideas crucial to both artists: abstraction, beauty, spirituality, and the role of history and politics in art. To convey the breadth of the Neue Meister collections, the curators have also selected 13 paintings from the period between Friedrich and Richter, installing them within the Getty Museum's permanent collection in provocative pairings designed to highlight important themes of German art in this period.

I am extremely grateful to the Staatliche Kunstsammlungen Dresden for generously sharing with us such a significant part of their collection and for being such gracious and thoughtful collaborators. Its General Director, Martin Roth, has been a great colleague with a truly expansive view of how such collaborations can provide inspiration for the institutions and our audiences alike.

I am also deeply grateful to Gerhard Richter, who has been an enthusiastic third partner on this project. Having already developed close ties with the Dresden State Museums, he has selected for the exhibition a series of abstract works he painted in 2005 and proposed an installation that would place his work in a stimulating continuum with those of his forebears. I am especially thankful to the owners of these recent paintings, the Museum of Modern Art, New York, Leonard and Susan Feinstein, and Mitzi and Warren Eisenberg, who have agreed to part temporarily with their spectacular new acquisitions in order to make this exhibition possible.

The exhibition *From Caspar David Friedrich to Gerhard Richter: German Paintings from Dresden* and the accompanying catalogue represent a most fruitful collaboration between curatorial departments of the Galerie Neue Meister and the Getty Museum. At the Getty, Jon Seydl, Associate Curator of Paintings, spearheaded the project, working with his fellow Associate Curator of Paintings Mary Morton under the direction of the Getty's Curator of Paintings, Scott Schaefer. In Dresden, Ulrich Bischoff, Director of the Galerie Neue Meister, led the collaboration, aided by Birgit Dalbajewa, Elisabeth Hipp, and Gerd Spitzer. Anna Greve in Dresden and Jon Seydl in Los Angeles oversaw the production of the catalogue. I greatly appreciate all their efforts in bringing this unique project to the Getty.

Michael Brand
Director
J. Paul Getty Museum, Los Angeles

Foreword

The Staatliche Kunstsammlungen Dresden are among the most important museums in the world. A total of 11 museums provide a thematic diversity of a unique kind. In 2010 this association will be 450 years old. Despite all the historical and political ups and downs, and small and large tragedies in their history to date, the collections have shaped and stabilized the profile of the city of Dresden and the state of Saxony. Only with this strong identity has it been possible for the city, even after National Socialism, the Holocaust, the campaigns against "degenerate art" and the difficult period of Communism, as well as the economic problems after reunification in 1989, to find itself once again at such an impressive speed. Within a very short period of time, Dresden has rejoined the circle of European art cities. Only a few examples of the magnificent, comprehensive art collections are named here: the unique Green Vault with the Treasure Chamber of August the Strong, the Porcelain Collection with porcelain from Meissen and East Asia, the Cabinet of Prints and Drawings with its extensive inventory, the Old Masters Gallery rich in key works from European painting, and the treasures of the Armory still slumbering in the repositories which from 2010 will be able to be rediscovered. These museums form the core of the art and cultural landscape of Dresden, at least since the return of thousands of art works from the Soviet Union in 1956 to 1958, which had been confiscated in 1945 by the so-called "trophy commission" of the Red Army.

The Galerie Neue Meister was only established as an independent museum in the wake of these events, even though the efforts to establish an independent gallery of new masters go back much further. Its inventory reflects to a special degree the bridging of the gap between the beginnings of the 19th century up to the present time. The Dresden art collections have always been a multifaceted point of attraction for artists from all nations. Ulrich Bischoff, the director of the Galerie Neue Meister, put it nicely: "artists love museums," and with this he referred to the fact that the Dresden museums in particular have always been, since their establishment, important centers for study and excursions for artists from all over the world. Caspar David Friedrich worked in Dresden, the city which exercised a magic attraction upon him. For Gerhard Richter as well, the close association with the museums in connection with his study at the Dresden Art Academy was part of his daily life. Both artists have not always been recognized in Dresden; nevertheless, despite all their differences, they have clearly left their mark on the city's identity. The real significance of Caspar David Friedrich's art was only discovered long after his death. Gerhard Richter, too, had a hard time with his art in the Communist part of Germany and left East Germany in 1961 to live in Dusseldorf, where he also taught and worked. The psychological distance from his home town of Dresden was correspondingly great. Therefore it seems to me to be a specially propitious gift that in 2002 Gerhard Richter again turned toward Dresden and its museums. For this gesture, which now will also benefit the J. Paul Getty Museum, my colleagues and I are very grateful to him. Apart from the works of Friedrich and Richter, a selection of paintings from the Galerie Neue Meister now also comes to Los Angeles, symbolizing the cultural identity of a great city of art in old Europe now in a period of momentous change—a wonderful counterpart to Los Angeles, the metropolis in which art with and through the Getty Trust increasingly represents an identifying characteristic.

The establishment of the Gerhard-Richter-Archive at the heart of the Staatliche Kunstsammlungen Dresden, which in future will also be closely associated with the Getty Trust, deserves special mention. At first sight it may seem to be somewhat absurd, but the Getty Trust and the Staatliche Kunstsammlungen Dresden are, precisely because of their great differences, perfect partners. Amidst the ongoing changes, both institutions are aware of their tasks—here the fast-changing Pacific region, there the east European countries

transforming at breakneck speed—in which education and research will play an imminent role.

I would therefore like to thank Deborah Marrow and Joan Weinstein for their cooperation in various research projects including the culture transfer with Russia. I also thank Tim Whalen and the Conservation Institute for research in connection with the restoration of the Green Vault and in particular for advice after the devastating flooding of the Elbe in the summer of 2002. My special thanks go to Scott Schaefer and Mark Leonard as well as Jon L. Seydl who contributed a great deal to the realization of this exhibition project. Norbert Arns from Gerhard Richter's studio was a great help. I would like to express special thanks to Michael Brand. His realistic and hands-on approach, coupled with his great expert knowledge, has made it possible to move this exhibition project very quickly from its conception to the phase of realization. Further projects such as that of the Sculpture Collection, the Green Vault, and that of Bolognese painting in the Old Masters Gallery promise to make the exchange between the Getty Trust, the J. Paul Getty Museum, and the Staatliche Kunstsammlungen Dresden into a veritable new model of cooperation between two very independent world-class museums. I would like to express my special thanks to Gerhard Richter.

Martin Roth
General Director
Staatliche Kunstsammlungen Dresden

P. S.: I very cordially thank Kurt Forster and Herb Hymans, who communicated an enthusiasm for this trailblazing institution of the future to me as a Visiting Scholar at the J. Paul Getty Museum in 1993. This enthusiasm has not subsided in me to the present day.

Acknowledgments

The exhibition and its accompanying catalogue—about works of art in dialogue—itself arose out of dialogues among scholars, both at the Getty and in Dresden. These points of contact—alternatively harmonious, electric, stimulating, resonant, and even at times discordant—remain the most meaningful and exciting aspect of the project.

This exhibition and catalogue emerged from the collaboration of many willing partners. We would first like to thank the Staatliche Kunstsammlungen Dresden, under the direction of Martin Roth, whose openness to a real exchange of ideas allowed this project to take shape. At the Getty, we are thankful to Michael Brand, the Museum's director, for his warm enthusiasm and constant support for this unusual and complex project. We also owe thanks to William M. Griswold, former Acting Director, and Mikka Gee Conway, Assistant Director for Museum Advancement, for their support at the planning stages. Quincy Houghton, Assistant Director for Exhibitions and Public Programs at the Getty, ably negotiated every practical complexity. Likewise, we are indebted to Scott Schaefer, Curator of Paintings, for his wise counsel, boundless enthusiasm, and willingness to experiment, and especially to Mary Morton, Associate Curator of Paintings, whose intellect, wisdom, and gracious diplomacy shaped the project early on.

The entire staff of the Galerie Neue Meister in Dresden took on the challenge from the beginning, committed to a rigorous, intellectual rethinking of their collection, all while working around a difficult schedule. Their resolve for a meaningful catalogue to mark the collaboration between our institutions came at exactly the right moment. In particular, two curators, Birgit Dalbajewa and Gerd Spitzer, were remarkably forthcoming and staunchly dedicated to a more nuanced understanding of this material, and the dialogue with Elisabeth Hipp now at the Gemäldegalerie Alte Meister pushed the project to a more substantive and rigorous level.

In addition, working with the Atelier Gerhard Richter has been a distinct pleasure. Gerhard Richter's decision to include the *Wald* series made the project come to life, and his support for the exhibition, and his subtle, but crucial, retooling of its premise has made the project more exciting and consequential. Likewise, Norbert Arns and Konstanze Ell could not have been more gracious, straightforward, positive, and energetic, and without their many contributions, this exhibition could never have taken place.

The designers Patrick Fredericksen and Emily Morishita developed the striking installation, handing the complexities of the exhibition's two parts with aplomb. We are grateful as well to Gerhard Richter and Norbert Arns for their initial ideas for the Friedrich and Richter galleries.

A wide array of colleagues at both institutions created this catalogue and exhibition. In Dresden, the team from the conservation department of the Gemäldegalerie Alte Meister and the Galerie Neue Meister—led by Marlies Giebe, and including Axel Börner, Günther Ohlhoff, Hartwig Hänsel, Adam Kalinowski, and Wilfried Neumann—prepared the works for travel, and Catrin Dietrich, Barbara Rühl, and Flavia Sommer helped enormously with the administration of the project. At the Getty, we must single out Sophia Allison, Mari-Tere Alvarez, Miranda Carroll, Cherie Chen, Catherine Comeau, Susan Edwards, Stephanie Ford, Sally Hibbard, Sandy Johnson, Amber Keller, Rael Lewis, Bruce Metro, Tami Philion, Merritt Price, Betsy Severance, and Yvonne Szafran for making the exhibition happen. Katrina Mohn deserves special thanks.

Both Getty Publications and Verlag der Buchhandlung Walther König have worked heroically to create the catalogue. In Cologne, Herbert Abrell has forged a publication of great distinction in a short amount of time. Mark Greenberg's organization and strategizing at the Getty was vital, and we would especially like to thank Anna Greve in Dresden for her calm coordination, lightning speed, sound advice, and intelligence while editing the

volume. Sean Gallagher, Uta Hoffmann, and Robin Ray capably translated and copyedited the manuscript, along with Fiona Elliott and Catherine Schelbert, while Lena Mozer and Ernst Georg Kühle were responsible for the design and typography.

Jeanne Nugent graciously shared forthcoming research, as did Michael Duffy, Cordula Grewe, and Karen Lang. We are also grateful to Scott Allan, Virginia Brilliant, Elaine Budin, Jens Daehner, Charlotte Eyerman, Marian Goodman, Mollie Holtman, Kara Kirk, Mark Leonard, Jean Linn, Ann Lucke, Daniel McLean, Patrick Pardo, Linda Pellegrini, Stefanii Ruta Atkins, Travis Schlink, Eike Schmidt, Kabir Singh, Susan Solof, Ann Temkin, Jody Udelsman, Julia Wai, and Anne Woollett for their contributions to the project.

Ulrich Bischoff
Director
Galerie Neue Meister
Staatliche Kunstsammlungen Dresden

Jon L. Seydl
Associate Curator
J. Paul Getty Museum

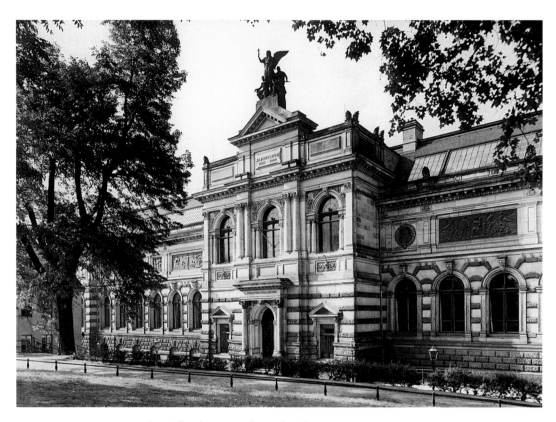

Fig. 1 Albertinum, Northeast elevation, center part, 1884–87

ULRICH BISCHOFF

The History of the
Galerie Neue Meister

"Dreßden has a grand and solemn setting"
(Heinrich von Kleist, 1801)

Every museum and every paintings collection has its own unmistakable character. This is certainly true of the Galerie Neue Meister as well. Since 1959, the museum has operated independently—as the younger sibling of the world famous Gemäldegalerie Alte Meister at Staatliche Kunstsammlungen Dresden, home to the *Sistine Madonna* by Raphael. What makes Dresden's Galerie Neue Meister unique? How did it come about? What future development might occur in the Gallery's structure?

The museum's location has influenced the collection in a wide variety of ways and continues to do so:

> Dreßden has a grand and solemn setting, amidst the encircling heights of the Elbhöhen, which surround it at some distance: as if through deep respect they dare not advance further. The river takes sudden leave of its right bank and turns quickly towards Dreßden, to kiss its darling. (This praise of the city was written in Leipzig by Heinrich von Kleist to his beloved Wilhelmine von Zenge on May 21, 1801, as he looked back upon his stay in Dresden.)

Beyond the city's beauty and charming setting, the existence of the art collection, initially in the possession of the Prince-Elector, then of the King, and finally of the state, was even more important to the founding of the Galerie Neue Meister and the support of art in general. Additionally, the importance of the Art Academy in Saxony's royal capital continually increased. While Caspar David Friedrich and the Norwegian Johan Christian Dahl had been denied full professorships at the Art Academy in the early 19th century, in the 20th century the institution, through its full professors Oskar Kokoschka and Otto Dix, had a marked influence on the development of painting in Dresden.

"No draft of air penetrates into the enduring Dresden art world"
(Hans Posse, 1921)

The enormous draw of the internationally renowned painting collection was extraordinarily important to Dresden's reputation in the 18th, and especially in the 19th and 20th centuries. Artists and art lovers from across Europe came to Dresden, particularly to see the Italian and Northern masterpieces. A look at these works, however,

is a look into the past and can limit attentiveness to the art of the present. Hans Posse (Gallery Director from 1910 to 1942) repeatedly pointed out the danger of such neglect:

> In the 19th century the fame of the Dresden Galerie Alte Meister inhibited more than promoted the creation of a department of newer art. Although Dresden was one of Germany's most influential art centers in the first half of the century, it was less a lack of acquisition funds than a cultural policy that was fixated on the past, which hindered the collection's extension into more recent times.

To remedy this discrepancy and reflect the significance of the collection's substantial growth, a new building for the "Newer Masters" was planned and begun even before World War I, but for financial and political reasons this edifice was never completed. Even though Posse was not one of Germany's most prominent defenders of contemporary art, he found himself subject to a degree of public defamation from 1930 on. Finally, at the beginning of 1938, he was obliged to apply for an early pension. On Adolf Hitler's personal directive, he took office again in June of the same year, however, and a year later was entrusted with the "special assignment Linz," working until his death in December 1942 on plans for a grand Führer-Museum, to be based on an inventory of purchased, confiscated, and stolen artworks. His successor as gallery director and special assignee in Linz was the art historian Hermann Voss.

After World War II the bulk of the collection's inventory was transported to the Soviet Union. The remaining works by new and old masters were shown in an interim exhibition at Pillnitz Castle. Three years after the Soviets returned a large number of paintings, the independent board of management for the new masters collection was founded. Its goal, as articulated by the leadership of the German Democratic Republic (GDR), was to combine curatorship of the existing art inventory—primarily German Realism—with the systematic development of a collection of national and international art (primarily from countries with Socialist governments), which was to coalesce into a historically comprehensible and logically consistent overview of Socialist Realism. This goal was nearly achieved when the newly structured Gemäldegalerie Neue Meister was inaugurated on October 20, 1965, in its new location in the Albertinum (fig. 1).

Acquisitions and Losses

The particular nature of the Dresden collection was formed through its complicated history of acquisitions. Its dark side includes almost inconceivable losses from the Nazi "Degenerate Art" campaign and destruction during World War II.

A fortunate decision, however, was the 1840 purchase, from the estate of Johan Christian Dahl, of Caspar David Friedrich's painting *Two Men Contemplating the Moon* (1840, p. 45), a work that later inspired Samuel Beckett to write *Waiting for Godot*. After 1843, the endowment from the former cabinet minister, Bernhard von Lindenau, who had also been chief superintendent of the royal collections, and who had donated ten years of his retirement pension as an acquisition fund, allowed the gallery to acquire a good dozen "patriotic pictures," including *Bridal Procession in a Spring Landscape* (1847) by Ludwig Richter. In 1874, when a short "Wilhelmine" phase began after the victory

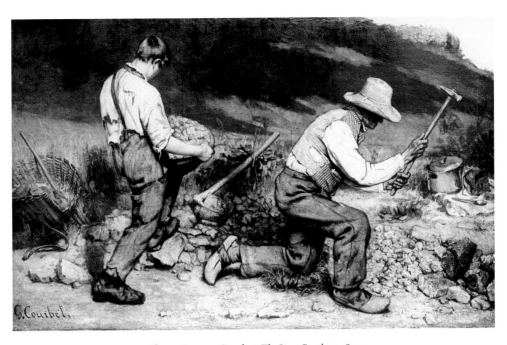

Fig. 2 Gustave Courbet, *The Stone Breakers*, 1849
Oil on canvas, 159 × 259 cm, Galerie Neue Meister,
Staatliche Kunstsammlungen Dresden, Gal. Nr. 2522 (lost during World War II)

over France in the Franco-Prussian War, the Saxon parliament passed a law to fund new acquisitions for the Gemäldegalerie. The museum used this fund, available until 1884, mainly to purchase Orientalizing genre paintings, very popular at the time, such as *The Feast of the Dead in Cairo* painted by Karl Wilhelm Gentz in 1872. In 1879, one of Dresden's citizens once again furthered development of the contemporary art collection. The real estate magnate and paint manufacturer Max Heinrich Eduard Pröll-Heuer specified in his will that works by "excellent, living German artists" were to be purchased annually from the interest earned on his fortune. Thus between 1890 and 1930, around 90 works of art were acquired, including masterpieces by Lovis Corinth, Ferdinand Hodler, Gustav Klimt, Max Liebermann, Adolf Menzel, Karl Schmidt-Rottluff, and Max Slevogt. From these Pröll-Heuer acquisitions, 21 works were lamentably lost during World War II, including Gustave Courbet's 1849 masterwork, *The Stone Breakers* (fig. 2). This event in the Gallery's history later inspired Philip Hook, the senior director of Sotheby's, to write his fascinating novel *Stonebreakers*. Even before the outbreak of World War II, during the summer and autumn of 1937, 54 paintings were removed as "degenerate art" as part of the confiscation campaign ordered by the Nazi propaganda ministry. Among these were works by Max Beckmann, Marc Chagall, Lovis Corinth, Otto Dix, Karl Hofer, Vasily Kandinsky, Ernst Ludwig Kirchner, Paul Klee, Oskar Kokoschka, Emil Nolde, Max Pechstein, and Karl Schmidt-Rottluff. Likewise, among a number of works by Edvard Munch wrested from Dresden's holdings, two paintings, *The Sick Child* of 1907 (London, Tate Gallery) and *Life* of 1908 (Oslo, Munch Museum), were purchased from the Berlin collection point by the Oslo art dealer Harald Holst Halvorsen in 1937, saving them from destruction.

From Caspar David Friedrich to Gerhard Richter

"its head turned to look forward"

The purchase of the above-mentioned paintings by Edvard Munch in 1926 and 1928 makes clear that purchases were based on scholarly acquisition guidelines and on the high standards of previous acquisitions—among them the extraordinary collection of Old Masters. Purchases were made to supplement either works by German masters or artists working in Dresden, such as Canaletto, Dahl, Friedrich, and the artists of *Die Brücke*, or to support important works already in its possession. Ideally such regional links, as now with works by the Dresden-born Gerhard Richter, lead both nationally and ultimately internationally into the core of the Galerie Neue Meister's collecting and exhibiting activities. This is how an art collection attains its unmistakable character.

In August 2004, exactly two years after devastating flood of the Elbe that threatened the very existence of the city's art treasures, an exhibition of the work of Gerhard Richter first demonstrated the artist's substantive relationship to the Dresden art collection, a close connection that had remained hidden until then. In *From Caspar David Friedrich to Gerhard Richter,* three halls with about 40 works by Richter were integrated into the permanent collection in the Albertinum's Oberlichtgalerie. The press duly celebrated this event.

> The permanent loan is, for Dresden, a wonderful shock. For at one blow this equally blessed and maltreated place, which so loves to bask in the glory of its past and wallow in the pain of its losses, has been wired directly into the present. It is as if the city, with one jerk, has had its head turned to look forward (Heinrich Wefing, *Frankfurter Allgemeine Zeitung*, August 20, 2004).

We now await the completion of the renovations to the Albertinum, after which the sculpture collection, which its outstanding examples of ancient and Baroque art, and the Galerie Neue Meister, with its Romantic, modern, and contemporary art, will find themselves under the same roof. With our eyes directed firmly ahead, we will achieve our goal of gaining a new relationship to the old treasures, and a better understanding of our contemporary world.

ELISABETH HIPP

Paintings from the Galerie Neue Meister at the J. Paul Getty Museum

Juxtapositions

This book accompanies an exhibition divided into two sections. Although each section is laid out differently, they have one thing in common: they both juxtapose art works from various historical contexts.

Thus, one section presents a number of works by Caspar David Friedrich (1774–1840) and Gerhard Richter (b. 1932) in separate galleries. When traversing these rooms, showing the paintings by Friedrich, impressions of Richter's paintings linger in memory, and vice versa. The other section establishes relationships among works from Dresden's Galerie Neue Meister to works in the permanent collection of paintings in the J. Paul Getty Museum. This text concerns itself with this latter section, in which pairs and groups of works have been carefully assembled, with particular attention to the context of the room.

The majority of paintings selected from Dresden are by German painters from the 19th century to the present. This emphasis is primarily a result of the structure and history of the Galerie Neue Meister collection.[1] Yet it is art-historically striking: after all, the period around 1800 (thus including Friedrich) is viewed as the beginning of the modern age that ultimately led to contemporary art, represented here by Gerhard Richter. As the exhibition emphasizes German painting in the broadest sense—here including the Swiss artist Arnold Böcklin—visitors have a chance to become acquainted with protagonists of salient importance in German art history, and often those linked with Dresden's particular history of art.

No attempt is made to derive any specifically "German" characteristics from the paintings. The idea that there are intrinsic German characteristics has its own history. Consequently, this idea, particularly within the last few years in German art historiography, has been repeatedly explained, criticized, and demystified in terms of its own historical conditionality.[2] It cannot be denied, however, that particularly in the 19th century many German artists consciously wore their origin, and to some extent also their political convictions (which were not always patriotic), on their sleeves and expressed these ideas and problems of national identity in their art as well. Similarly, one should not forget the cultural-political (mis-)use of art, especially in the 20th century.[3] Yet such political and ideological contexts identify only some of the parameters within which art is created. The individual decisions of the artists that result in the creation of the works of art are influenced by many additional factors, including the study of art from other countries and eras, the prevailing artistic norms and the discussions around them, the artists' social positions, and the social demands placed on them as artists. The context in which a work is created is therefore vividly communicative and complexly multilayered.

The diversity of combinations with "partner works" from Los Angeles is intended to leave the viewer open to this complexity. These works often come not only from other countries, but also from other time periods. The painting collection of the Getty encompasses the history of painting from the Middle Ages to 1900. Their juxtapositions with the Dresden pictures will thus inspire "conversations" between paintings and artists across geographical and temporal limits, and between two completely different collections, allowing visitors to gain new insights into the individual works of art. Comparisons have long been central to art history, represented particularly prominently by the early 20th-century art historian Heinrich Wölfflin (1864–1945). With the introduction of double slide projection, this approach took center stage also in the teaching of art history.[4] That the comparison method can also provide interesting insights in a looser sense, is shown by exhibitions in which artists rearrange works in museums associatively and according to their own criteria, or present them in a context with their own works; this is done from time to time in Dresden.[5] The juxtapositions presented at the Getty have been conceived by art historians, but because the choice was restricted to the inventories of the two collections, association also plays a productive role here.

A total of 13 combinations of pictures are integrated into the J. Paul Getty Museum's permanent galleries. No comparisons are forced upon the visitor and in some cases the conversation is extended with additional works of art. The text that follows gives clues in some cases to the contexts that have influenced the artistic decisions and the specific characteristics of the paintings. In the interests of conciseness (as well as the free-flowing layout of the Getty's galleries) it for the most part refrains from following a sequence dictated by chronology. While the space prohibits an exhaustive account of all important aspects of the individual works, further information regarding the works from Dresden can be found in the catalogue entries.

Historical distances

Ercole de' Roberti's *Saint Jerome in the Wilderness* (fig. 1) and Werner Tübke's little painting *Requiem* (p. 75) cover the widest temporal span of all the pictorial encounters. Roberti (1456–1496) was able to live out his life in his hometown of Ferrara in the position of court artist after having produced important works for various clients in Ferrara and Bologna. Tübke, born in 1929 in Schönebeck, near Magdeburg (d. 2004), was one of the most important artists in the German Democratic Republic (GDR). He represented that state in 1977 in the Federal Republic of Germany (FRG) at the international art exhibition *documenta* in Kassel and was repeatedly awarded public commissions. Artistically however, he trod paths, that did not always conform to party doctrine.[6] Despite the temporal distance and the different living and working conditions of the two artists, an examination of their pictures reveals some similar traits.

Roberti's early work, created in the 1470s,[7] shows Saint Jerome as a hermit in the stony desert. Wearing a penitential robe, the church father sits before a hermitage built into the rock and gazes at a crucifix he holds in his left hand. In his other hand he clutches the stone with which he chastised himself in response to temptation. Besides the stone and crucifix, he is accompanied by another of his attributes, the lion from whose paw, according to legend, Jerome is said to have removed a thorn, and who remained faithful to him since that time. In a nook inside the rudimentary building

one can make out two more of the saint's attributes: a cardinal's hat— alluding to his historical role as secretary to Pope Damasus (the College of Cardinals had not yet been established)—and a book, which refers to Jerome's erudition as well as to his translation of the Bible into Latin. Thus, the hat and the book together recall Jerome's significance to church history. Roberti presented the saint, widely revered in the 15th century, as an ascetic with thin, sinewy limbs. The hermitage, often shown in other

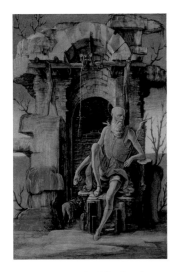

Fig. 1 Ercole de'Roberti,
Saint Jerome in the Wilderness, ca. 1470
Tempera on panel, 34 × 22 cm,
Los Angeles, The J. Paul Getty
Museum, 96.PB.14

artists' paintings as only a cavelike rock formation, is shown here as a more elaborated architectural form: carefully constructed walls rise up out of the rock. With the niche for the book and hat and a bell mounted on a beam, Roberti created a particularly satisfying home for the Doctor of the Church. In the converging lines of this aedicule, the painter simultaneously demonstrated his mastery of the laws of central perspective. The coloration underscores the desert location: earthy and ochre tones dominate while the sky in the background glows blue. The sun bathes the saint in bright light, and the cardinal's hat gleams from the depths of the hermitage, forming the center of the composition. The often-mentioned "linear" style of Roberti's early work appears in the detailed drapery of the penitential robe, in the curls of the beard, and in the pattern of the rocks to the left. The graphic quality and dry texture remind the viewer of Andrea Mantegna (ca. 1431–1506), although Roberti would have also encountered comparable stylistic characteristics in the work of other artists, such as his teacher Francesco del Cossa (ca. 1435–1476/77).[8] Roberti destabilizes the scholar's posture through the laterally composed countermovement of his arms and legs, extended and bent; the figure additionally twists towards the right, a position that is elegant in the upper body, but might appear also "mannered" and "daring," as some art historians have remarked.[9]

Werner Tübke's *Requiem* was created in 1965 at a time when the painter was involved in a larger project inspired by discussions about the employment of former Nazi judges in contemporary West Germany. The picture is a personal memorial, transposed into universal terms, to the victims of the Nazi regime and particularly to those murdered in concentration camps.[10] In his choice of medium, Tübke looked back to early panel painting. He used a mixed technique on wood reminiscent of tempera painting, with which he painted the dead, bathed in bright, almost glaring light on a sunlit yard. Depicted here is a man-made desert, the courtyard of a prison. In the background, confounding a sense of time, a wreath of honor hangs upon the wall. This therefore is not a real place, but a fictional, unreal one, which atmospherically articulates both past events and the sadness surrounding them. A dead tree at the left certainly recalls depictions of hermit saints—not only Jerome in the desert, but also Hieronymus Bosch's depiction of Saint Anthony (Madrid, Prado, ca. 1450). Not only is Tübke's tree dead, however, but also battered and mutilated, thereby reflecting and further illustrating the violence that the now lifeless bodies must have experienced. The white dove at the right further exemplifies the extent to which Tübke freely but ambiguously used Christian iconography. As the dove of peace it brings a note of hope into the painting, but simultaneously it recalls depictions of the Holy Spirit.[11] The dead bodies lie scattered on the ground, sharply foreshortened with their heads

towards the viewer. With this mode of representation Tübke may have been taking up—albeit with an inverted alignment of the prone bodies—one of the most important images of pathos, expressed in Mantegna's famous and often imitated depiction of the prostrate Christ (Milan, Pinacoteca di Brera, 1480s).[12] Completely concealed within a dark robe and sunk in deep mourning, the figure in the background on the right recalls a sculptural Pietà viewed from the rear.[13] Moreover, it is not inconceivable that Tübke, who was not only academically trained as a painter but also had a degree in art education, was consciously addressing another Renaissance topos here—one that found expression in the works of many artists—in which Timanthes, a painter from antiquity, depicted Iphigenia's mourning father with a veiled face, because he could not adequately express the depth of his mourning in any other way.[14] At the same time the configuration of reclining figures with one crouching dark figure awakens associations in form and motif—perhaps only coincidentally—with *The Night* by Ferdinand Hodler (Bern, Kunstmuseum, 1890), a painting different in terms of content (though also having death as a subject), but one that shares Tübke's narrative ambiguity and shows an approach to handling the composition in a decorative way, which also appears in Tübke's early works.

Thus one can find motifs of many kinds that could prompt art-historical memories in viewers and be understood as allusions to history and art history, without necessarily being able to pin down these references concretely in every case. The paint is applied with the finest brush; not only bringing to mind Old Master painting techniques, but also almost giving the impression of being drawn, rather than painted. The bizarre ridges and lines of the robes of the dead could almost compete with Roberti's ornamental drapery in Saint Jerome's gown.

Thus the two paintings are similar in their small format and intimate character (the one intended for individual meditation, the other for individual commemoration), and in certain artistic characteristics, particularly the "graphic" feeling of both panels. The comparison holds even though Tübke did not directly draw upon Roberti; he did not undertake his first trip to Italy until the 1970s, and then he was more influenced by—among other precedents—artists of the 16th century and Mannerism in particular. Tübke later pronounced: "The art of Tintoretto, El Greco and Veronese is as immediate to me as if these artists were my contemporaries."[15]

The aesthetic and intellectual "game" in Roberti's art served both the enjoyment and devotion of his patrons,[16] and generally speaking the artist was able to fall back iconographically upon an established and largely understandable vocabulary (which naturally could be enhanced with, for example, artful allusions). Tübke, however, lived in the modern era, and by freely drawing upon the "old" he accentuated a certain "intrinsic value" and ambiguous quality of his own art. He used ancient Christian pictorial content and earlier compositional forms, and he obfuscated the messages in his work, even while drawing on a well-known language of pathos. At the same time, he trod his own path artistically. In his early years, the iconographic vocabulary was already so refined and individualized that GDR state officials, who propagated Social Realism, occasionally became suspicious of him.[17] Thus upon closer viewing the historically contingent distance between the paintings ultimately increases again.

In a completely different manner the 1970 *Cloud Study* by Gerhard Richter (p. 77) manifests an almost ironic distance from older modes of painting, yet simultaneous-

ly links retrospectively to them. This work is paired in the exhibition with Caspar David Friedrich's *A Walk at Dusk* (1830–1835, fig. 2).

The break with generally accepted Christian iconography and academic rules appears distinctly just after 1800, for example, in Friedrich's landscape paintings. He saw landscape, a genre of relatively low status in the academic hierarchy, as a suitable medium for conveying religious or even political content. Additionally he loaded certain pictorial elements with new meaning—at least according to broadly accepted scholarly opinions—and he no longer accepted without question the older principles of composition and form. *A Walk at Dusk* depicts a man in a historicizing, *altdeutsch* [Old German] costume wearing a long scholar's coat and cap, who pauses at a megalithic grave during his evening walk through a tree-lined heath landscape. With the subject likely alluding to the mortality of all things, the rising moon is a "shimmer of hope"; according to Helmut Börsch-Supan, it is a reference to Christ and thereby to the hope granted to humanity despite the necessity of death.[18]

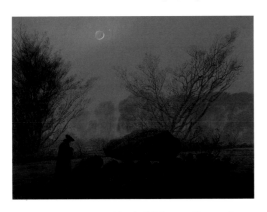

Fig. 2　Caspar David Friedrich, *A Walk at Dusk*, ca. 1830–35, Oil on canvas, 33.3 × 43.7 cm, Los Angeles, The J. Paul Getty Museum, 93.PA.14

Friedrich composed landscapes such as *A Walk at Dusk* in the studio, but he worked from nature studies, particularly drawings. Gerhard Richter's *Cloud Study* refers even in its title to such studies, perhaps the oil sketches and drawings produced in the milieu around Friedrich in Dresden at the beginning of the 19th century, including those of the Norwegian Johan Christian Dahl. Yet there are a number of differences. For instance, Richter did not describe nature directly; instead of painting from nature he painted from a photo that he took himself. Hence he used a principle similar to one he used in his paintings from the 1960s, made from black-and-white photographs. Since the painting takes on the photo's coincidental framing, its pictorial composition in turn is like an early Romantic, plein-air study, but in fact it is a work executed in the studio. Friedrich's *Walk*, however, represents a thoroughly composed studio painting, in which the artist strives for anything but an academic landscape. Although the light breaking through the clouds can superficially be associated with meaningfully loaded content, Richter's picture is not bound to this interpretation; no figure stands pondering here, expressly inviting us to reflect upon the heavenly light. *Cloud Study*, after longer viewing, rather raises the question of how reality is individually perceived and how it can be captured in a picture, and it points out the haziness of our perceptions of unadulterated nature.[19]

Old and new solutions

The historical distance between the paired paintings narrows in cases where 19th-century artists took "classical" Renaissance and Baroque pictorial solutions into consideration in their own works, solutions they could have seen in art academies and public collections. This transition was not seamless in terms of content, but astounding correspondences can be discovered.

Ludwig Richter (1803–1884) is associated with the late phase of German Romanticism. Originally from Dresden, he also worked there for the greater part of his life,

known primarily for his many popular illustrations and portfolios of prints. He started his career, however, with the resolute goal of becoming a painter, and during his stay in Rome from 1823 to 1826 he began developing his own concept of landscape painting.[20]

Notes by the artist as well as the paintings themselves demonstrate that Richter's approach to landscape arose from a conflict. History painting attracted him, particularly in Rome, but he "did not dare to take such a dubious step, as it seemed to me at the time."[21] Therefore, he began composing his landscape paintings with sophisticated content, according central importance to the staffage.

On the one hand Richter's early works from Rome quite obviously drew upon developments by German-speaking artists working there (primarily Joseph Anton Koch, who became Richter's teacher);[22] on the other hand he identified a series of historical inspirations in his diary—including Nicolas Poussin and, already highly esteemed by Johann Wolfgang Goethe, Jacob van Ruisdael.[23] In *Bohemian Pastoral Landscape* (*Landscape with Rainbow*; p. 61), created in 1840, many years after his return from Rome, Richter transferred to Bohemia (relatively close to his native Saxony) a scene of people crossing a ford, a subject that he had often painted in an Italian setting. Except for some vegetation that leads one to suspect that this is not an Italian landscape, the location remains unclear. The expectations placed upon the landscape painting, however, are the same as in his earlier works. The individual pictorial elements lead the viewer's gaze consecutively into the landscape: from the family representing the ages of man on the left across the sheepherding scenes in the middle ground, and then into the distance on the right, to the rainbow. The composition no longer corresponds in every respect to the common academic conception of a "classical landscape" as previously developed in the legacy of such painters as Nicolas Poussin and Claude Lorrain. No decorative trees provide framing on the right and left, and the view of the sky extends across the painting's upper half. Yet, the painter retained the layering of pictorial depth together with color perspective—one can see a blue-toned mountain range in the distance—following the old observation that things farther in the distance tend towards blue. One can gather from a number of Richter's remarks that he also wanted to express Christian content in his paintings. In this sense the interplay of the figures with nature, the flora and fauna, and the weather in the heavens opens a deeper level of meaning for viewers. The significant theme concerns man's journey through life and his quest for an "eternal homeland," as Richter referred to the hereafter, and the return home to God, symbolized by the rainbow.[24] Although Richter did not directly credit Friedrich, the rainbow is one motif in particular that this painter loaded with meaning in a similar spirit.

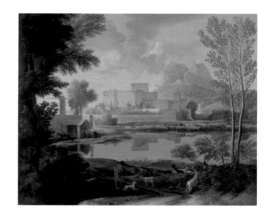

Fig. 3 Nicolas Poussin, *Landscape with a Calm*, 1650–51. Oil on canvas, 97 × 131.5 cm, Los Angeles, The J. Paul Getty Museum, 97.PA.60

One can regard Nicolas Poussin (1594–1665) in turn as one of the most important protagonists of classical landscape painting, and he was an important influence on subsequent generations of European artists. He produced his *Landscape with a Calm* (fig. 3) in Rome between 1650 and 1651 together with another landscape painting, its

pendant *Landscape with a Storm* (Rouen, Musée des Beaux-Arts), commissioned by the Parisian merchant Jean Pointel.[25] A large tree silhouetted against the light leads one into the composition from the left; another lighter, slimmer tree borders it on the right. Between them, the vista opens out into the deeply tiered landscape, past the rustic in the foreground to the large lake that casts back the reflections of another flock and the ancient buildings of a farmstead and a fortress or town. In the background, steep, craggy cliffs tower up into a sky filled with cloud formations. The eponymous calm is indeed visible: The lake remains still and clear; there is no movement in the soft trees on the right; and the leaves do not even seem to tremble. The shepherds go quietly about their daily routine, and only a galloping rider at the left suggests a hint of drama. The landscape's balanced composition and antique setting are characteristics one can also find in later classicizing paintings by other artists. In this picture and in its pendant Poussin likewise proved his mastery of optical principles: color perspective and aerial perspective, and the meticulous rendering of reflections.[26]

While Poussin's other landscapes mostly portray active literary, biblical or mythological protagonists whose emotions and destinies are reflected and amplified in the depiction of nature—such as in *Pyramus and Thisbe* (Frankfurt am Main, Städel, 1651)—the cast of characters here is reduced to the shepherds and horsemen, and no particular story is told. Indeed, the landscape is often considered, along with its counterpart, to be one of Poussin's few "non-narrative" landscapes. Nevertheless, these two paintings, whose titles come from their description by Poussin's early biographer André Félibien, have had further interpretations. For example, some have seen this painting and its pendant, the depiction of the storm, as symbols for the vicissitudes of life.[27] In fact, in 1648 Poussin entertained the thought of creating, as an analogue to his *Seven Sacraments* series, a series about the storms of which human life is at the mercy.[28] Compared with Poussin's artful and impressive arrangement, Richter's landscape seems more modest, while sharing the pastoral subject. In the foreground of one of his early landscapes created in Italy, Richter also placed a shepherd or wanderer figure leaning against a staff, recalling the figure in Poussin's painting. Richter used similar figures in various compositions later on, too.[29]

If Richter, somewhat similarly to Poussin, took the difficulties of the human journey through life as the theme of his landscape paintings, then it seems reasonable that he also allowed himself to be inspired by such classical landscapes. In the "Thoughts on landscape painting," entered in his diary in 1830, he ascribes a "symbolic tendency" to Poussin in particular, but also to Titian: in an early painting Richter produced in Rome, he quoted from *The Feast of Gods* by Giovanni Bellini with additions by Titian (Washington, National Gallery of Art, 1514–29).[30] It is likely that he was referring to paintings that conferred meaning upon mythological figures, and that in his own paintings he used rustics instead of mythological figures as intimations ("*Fingerzeige*")[31] about the landscape. Thus, Richter's shepherds are really different from those in the Getty Poussin in that Richter depicts an entire family whose members become protagonists of a narrative of crossing a ford. Their cheerful attitude likewise sets them apart from Poussin's Arcadian shepherds.

Richter's piety as a devout Protestant, against which his use of the "journey through life" metaphor should be viewed, stands in an intriguing relationship to the attitude of the Catholic painter from France, who has repeatedly been associated with

Stoic ideas. Richter's decision to use "native" landscape also points out the differences in the lives of the two artists. Lacking money, Richter did not make another trip to Italy, but Poussin, who already had a base of wealthy customers when he created the landscape considered here, was able to choose to live in Rome. He had lived there since the 1620s, and wanted to return in 1642 when the working and living conditions as the "premier peintre" at the royal court in Paris (where he had arrived in 1640) no longer pleased him.

All told, this juxtaposition testifies to the positive impulses of a school of landscape painting considered exemplary at academies and art schools throughout Europe. It also shows that even the stronger of Richter's later "homeland" landscapes bore to some degree his Italian experiences within them—experiences Richter would certainly have refreshed had he had different financial and personal circumstances.

In a more direct manner, Julius Schnorr von Carolsfeld's (1794–1872) *The Family of Saint John the Baptist Visiting the Family of Christ* (p. 51) draws on prior artistic solutions. Without the works of North Alpine masters such as Martin Schongauer and Albrecht Dürer his painting would not have been conceivable. Yet the painting styles of Early and High Renaissance Italian art also seem to play a role in this picture, which the Saxon artist completed during a residence in Vienna, before he traveled to Italy. Although he apparently inspired Michelangelo,[32] Fra Bartolommeo (Baccio della Porta, 1472–1517), who was active in Florence as a Dominican brother and painter, is generally less well known today than his more famous contemporaries, including Raphael. Yet a glance at Fra Bartolommeo's *The Rest on the Flight into Egypt with Saint John the Baptist* confirms a general connection between Schnorr's painting and predecessors from that epoch. In Rome, Schnorr joined the "Nazarenes," a circle of young German painters who strove to achieve the ideal of an archetypal Christian style of art, for which they found the works of Raphael, but also of Dürer and others, to be especially fundamental and exemplary.[33] Though it is less likely in the case considered here, in many of his works Fra Bartolommeo can be associated with the Florentine political and religious reformer Girolamo Savonarola's idea of clear, modest, and simple religious art.[34] Against this backdrop the two artists' intentions appear to be distantly related, and one could assume the same for their paintings as well. Yet it can be clearly felt from Schnorr's painting that he is programmatically appropriating an older pictorial language—here from Northern predecessors, among others—and earlier painting techniques. With its depiction of the "Madonna in a Rose Garden" on the left, and a scene of the Visitation reinterpreted as an encounter among Joseph, Zachary, Elizabeth, and John, the painting seems somewhat fabricated. Here too we become aware of the temporal distance, which in the same period prompted Friedrich in a completely different manner to renew religious painting through landscape motifs.

Another influence that became increasingly important in the 18th century, besides "classical" Roman landscape painting, was 17th-century Dutch landscape painting. A selection of these pictures in the Getty collection is combined here with Carl Gustav Carus's *Oaks by the Sea* (p. 57) of 1835.

Carus (1789–1869) was a doctor by profession and a self-taught artist. He came to Dresden in 1814 as director of the new Academy for Surgery and Medicine, and in 1817

he met Friedrich, who became his friend and role model for some time.[35] Carus certainly became familiar with 17th-century Dutch landscape painting in the Dresden Gemäldegalerie, and he considered Jacob van Ruisdael (1628 or 1629–1682), along with Claude Lorrain, as the "progenitor" of "real landscape art."[36] Paintings such as *A View of the Maas at Dordrecht* by Aelbert Cuyp (1620–1691), *A Panoramic Landscape* by Philips Koninck (1619–1688), and *A Wooded Landscape with Travelers on a Path through a Hamlet* by Meindert Hobbema (1638–1709) demonstrate salient features of Dutch landscape painting. These include the lack of mythological content; the concentration on nature that, while composed in the studio, was intended to reproduce the Dutch landscape more or less realistically; and the importance of the sky, which in Koninck's panoramic painting—he specialized in such panoramas—takes up almost half the pictorial surface and is enlivened by clouds.[37] Despite his fastidious style, Carus handles trees and grass in a manner that seems somewhat rough in comparison to Hobbema, a pupil of the venerated Jacob van Ruisdael, who specialized in representations of forests and treed landscapes, but it is also concrete and arresting. The plasticity of the bark and cliffs encourages closer viewing, drawing the viewers' gaze searchingly along the painted structure like an exploring natural scientist, as befits Carus's profession as a physician.

Somewhat different in atmosphere from the examples considered above is the juxtaposition of Joseph Wright of Derby (1734–1797) and Wilhelm Leibl (1844–1900). Wright of Derby was a popular portrait painter in the 18th century, although in a certain sense he was a maverick working on the periphery,[38] and he was certainly not considered to be an important influence in the 19th century, while Leibl was of a later generation than the other painters considered in this section of the essay.

Leibl's *Portrait of Baron Wilhelm Schenk von Stauffenberg* (1877, p. 63) testifies to the artist's precise observation and exact reproduction of the officer's appearance, including his sternly combed-back hair, his bushy mustache, and his hands, no longer young. The three-quarter profile view further amplifies the painting's impression of naturalness: the sitter does not look at the viewer, but surrenders himself instead to close study. This "realistic" depiction, which certainly follows in the legacy of Gustave Courbet, initially departs from Wright of Derby's slickly painted *Portrait of John Whetham of Kirklington* (ca. 1779–80), which depicts a posing gentleman, who gazes directly and self-confidently at the viewer. The painting was probably commissioned as one of three variations, together with the portraits of two other gentlemen, each of which were also painted in three variations. Wright of Derby painted two of the portraits, while the third was by Wright of Derby's colleague George Romney. The paintings were intended to be distributed as a kind of friendship pledge, so that each sitter should possess all three portraits.[39] Wright of Derby's clear portrayal seems immensely natural in comparison with portraits painted in continental courtly circles in the first half of the 18th century, especially in Whetham's casual posture and the individualized rendering of his features. Furthermore, Wright of Derby aimed for a natural feeling for the surface, particularly in the light and shadows of the face, and his loose, liquid brushstrokes contribute to the animated expression. British portraits of citizens and nobility became influential on the continent in the second half of the 18th century, precisely due to such characteristics as these. Thus the portraits of Anton

Graff, for example, capture the sitter's individual characteristics without regard for social standing.[40] Such portraits as Graff's and indirectly, Wright of Derby's, thus ultimately created some of the prerequisites for Leibl's style of realism.

Without regard for borders

The relationships between paintings and artists following one another in close temporal succession prove to be more subtle. In Carl Blechen's *Ruins of a Gothic Church* (1826, p. 53) and Christen Købke's *The Forum, Pompeii, with Vesuvius in the Distance* (1841, fig. 4), a vertical format confronts a horizontal one, and Roman ruins face the overgrown ruin of a Gothic church at night. Købke (1810–1848) studied at the Royal Art Academy in Copenhagen, a school also attended by Caspar David Friedrich. Besides portraits, he painted landscapes and views within the town as well as numerous oil sketches. Beginning in the 1830s, Købke sought an ideal of classical simplicity. The *Forum*, finished in Denmark from sketches made in Italy, reflects this approach in its clarity of composition and light. The section of Pompeii he chose to depict, with its row of centrally placed columns receding in the distance and towering above the other ruins, is especially effective.[41] Blechen (1798–1840) produced *Ruins of a Gothic Church* three years after the young painter had traveled from Berlin to Dresden, where he met both Friedrich and Dahl. At the same time, the experience of seeing Meissen Cathedral might have also inspired the subject. Blechen painted the Gothic building with great precision but without completely developing its architectural context.[42] The sleeping pilgrim close to the chasm of a sundered crypt, and the altogether gloomy atmosphere of the overgrown ruin, which the daylight opposes in a hopeful manner, are romantic motifs in the legacy of Friedrich, combined with precise observation. It would be too simple to discern the antithesis of Classicism and Romanticism in Købke's and Blechen's paintings; both also exhibit divergent approaches towards representing the "real."

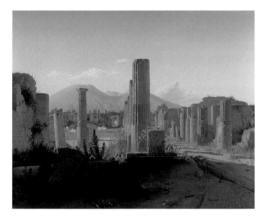

Fig. 4 Christen Schjellerup Købke, *The Forum, Pompeii, with Vesuvius in the Distance*, 1841
Oil on paper, mounted on canvas, 68.5 × 86.3 cm, Los Angeles, The J. Paul Getty Museum, 85.PA.43

At the same time, Købke's painting demonstrates how detailed studies could become the basis for a painting. In the exhibition, a small 1833 oil sketch created by Christian Friedrich Gille (1805–1899), *At the Weisseritz River in Plauen* (p. 55), has been consciously hung close to an almost contemporary oil sketch, the 1830 *Houses near Orléans* by Jean-Baptiste-Camille Corot (1796–1875), another by Simon Alexandre-Clément Denis (1755–1812), *Study of Clouds with a Sunset near Rome*, and the small *View of the Bridge and Part of the Town of Cava, Kingdom of Naples* by Jean Joseph Xavier Bidault (1758–1846). The cloud study by the Flemish painter Denis refers particularly well to the beginnings of this genre. Denis probably painted it at the end of the 18th century, while staying in Rome, in a circle of French artists following the legacy of the landscape painter Pierre-Henri de Valenciennes (1750–1819), who had been creating colored sketches of clouds in Rome since 1777. Valenciennes had returned to Paris in 1784 where he taught art, and Denis might have already met him there before his own

departure for Rome in 1786.[43] Denis's sketch thus once again clearly shows the historical horizon which Gerhard Richter relates to with his *Cloud Study*.

Given the general acceptance across Europe of oil sketches as a viable subgenre, Gille's sketch of the Weisseritz River in an autumn landscape seems international in this context, and very much in line with its time. In this regard, Hans Posse (Director of the Dresden Gemäldegalerie from 1910 to 1942) already recognized him as "a match for those of the School of Fontainebleau."[44] Oil sketches were occasionally produced directly from nature by artists in the 18th century (and probably even earlier) and grew increasingly common towards the end of the century, and they certainly were a commonly used tool throughout Europe in the 19th century. Ludwig Richter also expressed amusement in his memoirs about the vast number of oil sketches from nature produced by French artists in Italy, and that while there he and his friends had drawn from nature much more than they had painted from it.[45] Gille began producing oil sketches through the influence of his teacher Dahl. He also painted large-format, carefully executed paintings, but even if he may not have recognized the oil sketch as a genre of independent artistic value, he did see it as an independent means of expression, corresponding very closely to his approach to nature.[46] The studies by Denis and Corot testify to the wide use of studies done from nature in France, where artists and art schools accorded them a crucial and precisely defined role in the working process. Corot ultimately brought sketchlike characteristics into his large paintings, while the example by Bidault, with its close attention to detail, is a more finished example of this colorful preoccupation with nature.

Among the comparisons of works by artists who solved artistic problems in a time period relatively close to one another are *Starry Night* (fig. 5) by Edvard Munch (1863–1944) and *Summer Day* (p. 65) by Arnold Böcklin (1827–1901). In this case the Dresden painting is earlier: Böcklin created *Summer Day* in 1881, when he was preoccupied with the pictorial idea for *Isle of the Dead*, various versions of which he produced between 1880 and 1886 (one example in Berlin, Nationalgalerie). *Summer Day* appears to be the polar opposite of this famous composition, a happier, more positive counterpart.[47] The Dresden painting shows an idyll, a charming place. Towering poplars at the bend of a gently flowing river offer cool shadows to bathing and playing children. The light of the sun makes the foliage of the trees glitter against the shining blue sky, through which only a line of small clouds floats. The bathers gleam brightly, almost white, and they are reflected in the still water like the trunks of the trees. The painter has not formulated the figures' bodies in detail nor given them faces; they seem to be a part of nature and yet they stand out. In the background, at the distant horizon, a town or settlement is visible, and the flat roof of the building closest to the scene could indicate a location in Italy.

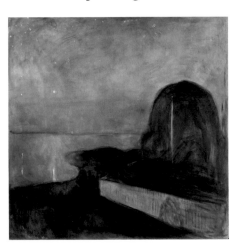

Fig. 5 Edvard Munch, *Starry Night*, 1893
Oil on canvas, 135.6 × 140 cm,
Los Angeles, The J. Paul Getty Museum,
84.PA.681

Böcklin composed this vertical format hermetically. Only on the left does one of the trees bump up against the edge of the painting; otherwise they do not overlap the

work's boundary. Balanced by small clouds in the sky, the bends of the river subdivide the foreground. The intensified luminosity of the colors is such that they barely correspond to reality. In the painting, the viewer thus has an opportunity to perceive both the design of a surface and a landscape painting with spatial depth. For this purpose, Böcklin applied the traditional method of color perspective.

To a degree, Böcklin's painting corresponds to 18th-century ideas of idyllic landscapes, untouched by time, although he himself approaches antiquity differently than the classicizing landscape painters a century earlier. The scene is suspended in time, and it is not clear whether the picture is set in the present, or whether it stems from the Renaissance or even antiquity. It thus refers to a happy condition outside the flow of time (though the mere existence of such a flow of time might nevertheless be indicated by the flowing river).[48]

The theme of bathers is an old subject in painting; Böcklin uses it, however, not just to depict nude bodies or a mythological scene. Böcklin invented the pictorial idea for *Isle of the Dead* for a customer in 1880. As requested,[49] it was a "painting to dream by"—a solemn quiet place, an imaginary island, and a melancholic picture bringing to mind death and a time long past. One can also view *Summer Day* as a type of dream picture, in the sense of a memory of a distant childhood. As in his other paintings, Böcklin is able to awaken feelings and moods in the viewer here without becoming concrete in the pictorial narrative. *Summer Day* is also notable because of the absence of clear mythological references. Here, one cannot find a secret comparable to that of *Isle of the Dead*.[50]

Compared with Böcklin's work, Munch's *Starry Night* seems almost abstract. The painting, created in 1893, shows a section of coast in Åsgårdstrand in today's Oslo Fjord, where Munch repeatedly stayed for longer periods in the 1890s. Many other paintings by Munch relate to the same location. The right side of the work is dominated by the shadowy outline of several intertwined willow trees, against which we see a white, longish reflection that does not appear in the second, later version of the picture (Wuppertal, Von der Heydt-Museum). A white fence that borders a garden slides diagonally into the picture on the right. The painter has reduced everything to basic forms engulfed in the nocturnal shadows; only the garden fence shines in the light from the stars scattered throughout the sky—stars glowing with shimmering blue, green, and violet tones, reflected in the blue ocean. Munch applied the paint in the dry manner typical for him at that time, applying it more thickly in some passages of the glowing sky, but also extremely thinly in others. In other places he smeared various colors together; in the treetops above the pasture they coalesce as a dark shimmer.

Munch's anti-naturalistic approach to landscape manifests itself here. His goal was to capture the emotional responses he experienced from viewing certain landscapes, and thus to reproduce something felt more than seen. Correspondingly, the painting is penetrating to viewers with its dominating blue color, its shining stars and their reflected light, and its mysteriously dark forms.

Munch shares with Böcklin this targeting of viewers' emotions to achieve a visual impression, which might awaken memories of related feelings. One way both painters achieve this effect here is by intensifying the colors beyond those found in nature, particularly in the unnatural blue of the sky. Another key similarity is the clarity with which the artists organize the paintings' surfaces.[51]

In fact, even though Böcklin was actually Swiss, Munch held him to be one of Germany's greatest painters. During a visit to Hamburg's Kunsthalle in 1891, Böcklin's *Sacred Grove* was the only painting that excited him.[52] As he wrote in 1893 in a letter from Berlin, Munch considered Böcklin equal in significance to the French artists of his time and placed Böcklin on a par with other representatives of "German" culture whom he revered: the artist Max Klinger as well as the philosopher Friedrich Nietzsche and the composer Richard Wagner.

Munch had a mixed reception in Germany: in 1892, his first exhibition in Berlin was accompanied by debate in the press, while in 1894, the writer Stanislaw Przybyszewski edited a book about Munch, with essays by four authors, including himself. In this book, the ideologically conservative Willy Pastor construed a link between Böcklin and Munch, which was also perceived by other critics at the beginning of the 1890s.[53] Yet this type of connection allows one to discover at most half of the truth. Thus, some also linked Munch's nighttime painting to the *Nocturnes* of the American Impressionist James Abbott McNeill Whistler, who was working in France.[54]

In 1905 the author Hermann Esswein again "sensed" a connection between Munch and Böcklin,[55] while in the same year Julius Meier-Graefe published a critical text on Böcklin, objecting to his late work (he appreciated Böcklin's works of the 1850s and 1860s) for, among other things, his seeming lack of interest in formal problems.[56] In any case, contemporary critics were faced with two individual and unique solutions to the problem of how to express feelings through landscape painting.

Through his writings, Julius Meier-Graefe, one of the most influential German connoisseurs of French painting, sought to cultivate the art historical and aesthetic understanding of French Impressionism among German audiences. In 1911, for example, he published a book about the work of Pierre-Auguste Renoir (1841–1919). In general among German artists around 1900, the Impressionist way of painting was considered a suitable and modern manner for reproducing nature. The co-founder of the Berliner Secession (1896), Max Liebermann (1847–1935), was especially important in this regard; he began to paint in a realistic manner following Adolph Menzel, and later in Holland took up naturalistic painting outdoors, eventually developing his own unique take on Impressionism.

If one compares Liebermann's *Portrait of Alfred von Berger* (p. 69) with Renoir's 1881 *Portrait of Albert Cahen d'Anvers*, major differences can be seen in the characters of the sitters. Renoir's painting, created the same year as the famous *Luncheon of the Boating Party* (Washington, Phillips Collection, 1880–81), and five years after *Dance at Le Moulin de la Galette* (Paris, Musée d'Orsay, 1876), places the sitter in an interior and shows him as an elegantly dressed gentleman with a carefully trimmed moustache. The light reflects softly, and Cahen d'Anvers's eyes suggest he is lost in thought, as though listening distantly to others speaking. In the background, the painter has sketched a salon with ornamental flowered wallpaper. The loose application of paint, which nonetheless coalesces into solid forms, conveys an elegant, light atmosphere, from which the sitter gazes back at the viewer with great immediacy. By contrast, Alfred von Berger, then Director of the Hamburg Schauspielhaus, appears communicative in Liebermann's 1905 painting, as if caught in conversation with the viewer. Liebermann recorded Berger's distinctive features with rough, fluid brushstrokes. Despite the

sitter's stockiness, heavy eyelids, and red, slightly shiny cheeks, he seems lively and witty. The choppy brushwork of the face, suggesting motion, further this impression. The painting concentrates completely on him, while a brown color fills the background without further details. Although one of the most important representatives of German Impressionism, in this case Liebermann was probably less influenced by French portraits in the style of Renoir than by the paintings of the 17th-century Dutch portraitist Frans Hals, which Liebermann repeatedly studied along with the works of Diego Velázquez and other Old Masters. The form of realism seen here led many to consider Liebermann one of the best portraitists of his time, but simultaneously gave him the reputation of an "apostle of ugliness."[57]

Like Liebermann, Lovis Corinth (1858–1925) also belongs, in a certain sense, to the circle of German Impressionists. One can only classify Corinth with difficulty, however, due in part to his preference for historical topics—typically the subject matter of historicizing salon painting. His mythological pictures seem ironic to some degree, and yet he took their topics seriously. He stressed his roots in French painting, but others claimed he represented a specifically "German" painting style; Meier-Graefe, however, emphasized the autonomy of his late work, which took its inspiration from many sources.[58]

Corinth's painting *Friends* (large version, 1904, p. 67) depicts a typical 19th-century subject, the languorous, female nude, with such precursors as Jean-Auguste-Dominique Ingres's *Odalisques* (1814 version, Paris, Musée du Louvre). The British painter John William Godward (1861–1922) was selected here as a counterpart to Corinth, and Godward's painting *Mischief and Repose* (1895, fig. 6), depicting two beauties devoted to idleness and pausing at best in anticipation of a lover, also seems to belong to this tradition, but here the painter has relocated the scene to Roman antiquity and scantily dressed the figures. The facial features and hairstyles recall Godward's Pre-Raphaelite forerunners, although his work more generally fits into the genre of salon painting using "classical" subjects, which particularly in England had formed a type of school led by such figures as Lawrence Alma-Tadema. The

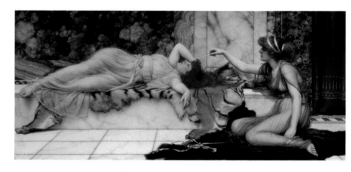

Fig. 6 John William Godward, *Mischief and Repose*, 1895
Oil on canvas, 58.4 × 130.8 cm, Los Angeles,
The J. Paul Getty Museum, 79.PA.149

smoothly painted, white skin of the women vies with the shiny surface of the marble, various kinds of which the painter (who trained for a while under an architect and designer) depicted with precision.[59] The viewer becomes a voyeur, and the beautiful women remain unapproachable.

By contrast, in Corinth's painting, the corporeality of the models gives them an immediacy and tangibility. The rapid application of the paint also invokes a palpable and impetuous sensuality, which the painter celebrates here. Moreover, in the confrontation between these two pictures, it becomes particularly clear that they originate from different collection contexts. It was certainly no accident that J. Paul Getty, whose personal collecting interests lay in ancient art and who later would build his

villa in Malibu in Roman style, selected a work from this classicizing genre in 1938.[60] The Dresden Gemäldegalerie, in contrast, acquired Corinth's painting in 1923 at a time when its director, Hans Posse, was consciously developing its modern section.

Among the early representatives of Expressionism are the founders of the artists group *Die Brücke*, which was established in 1905 in Dresden. Some of these painters, including Ernst Ludwig Kirchner and Karl Schmidt-Rottluff (1884–1976), had initially begun their careers by studying architecture. At first the young painters were inspired by the new art of the previous generation: Neo-Impressionism, Vincent van Gogh, and Edvard Munch. However, they ultimately developed a lively, colorful form of expression and something close to a group style, although their ways of painting changed and became more individual again after the most important members moved to Berlin in 1911.[61] Observation and visual reception, however, always were important for their work as points of departure, even if the artists amplified the impression into an individual artistic expression, which no longer seemed to be "natural" (like Impressionist paintings). Besides sharing a similar subject, this emphasis on

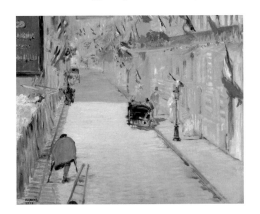

Fig. 7 Edouard Manet,
The Rue Mosnier with Flags, 1878
Oil on canvas, 65.5 × 81 cm, Los Angeles,
The J. Paul Getty Museum, 89.PA.71

observation relates Schmidt-Rottluff's work to Edouard Manet's painting *The Rue Mosnier with Flags* (fig. 7), which depicts the view from Manet's studio looking onto the Rue Mosnier on June 30, 1878, during the "Fête de la Paix" celebration.[62] The scene is flooded with bright daylight and dominated by pale colors, with the only saturated hues in the shutters at the top left, the flags, and the wagon on the right. In comparison, the broken colors used by Schmidt-Rottluff in his 1921 painting *Landscape in Rottluff* (p. 73) are extremely strong, even if more restrained than in his early period. While Manet's painting still develops spatial depth more or less with traditional perspective, Schmidt-Rottluff's painting breaks with this convention; both paintings, however, also treat the pictorial surface as a plane. While Manet's painting includes a political or social accent with a view of a man on crutches at the painting's left,[63] Schmidt-Rottluff, although not omitting the people on the village street, incorporates them into the overall composition, accentuating them too little for one to be able to ascribe any deeper significance to them.

Finally, a harmony of primarily formal character with psychological undertones emerges when two sculptures by the artists Paul Gauguin (1848–1903) and Jean-Joseph Carriès (1855–1894) interact in a fascinating arrangement with the self-portrait *Yearning* (p. 71) by Otto Dix (1891–1969), who, after an early Expressionist phase, later painted in a more detailed manner more influenced by Old Master painting. The sculptures include Gauguin's primitive *Head with Horns* (1895–1897, fig. 8), a work that draws on Polynesian art and South-Sea divinities,

Fig. 8 Paul Gauguin,
Head with Horns, 1895–97
Wood with traces of polychromy,
height (with base) 59.4 cm,
Los Angeles, The J. Paul Getty
Museum, 93.PA.14

which he represented in his album *Noa Noa*[64] and Carriès's head with animal ears, a self-portrait of the artist as an unhappily transformed King Midas (also known as *The Sleeping Faun*). The heads are similar in their isolation, but at the same time they come from different iconographical sources. The different postures of the heads seem, when looked at together, like various moments in one movement. Dix's self-portrait also describes a movement, a revolution around a center. Dix takes the motifs surrounding his head from the Christian tradition, interpreting himself as a type of religious center, but appears not to take this attitude completely seriously.

The benefit of juxtapositions

This exhibition reveals multiple layers of affinities before our eyes. Some paintings exhibit formal correlations, even though they originate from totally different historical contexts. Sometimes the artists are contemporaries, sometimes one of them set the example, and sometimes there are roots in art history. Even if there is no actual causal relationship between the pictures, one can discern more general art-historical relationships.

A great variety of pictorial languages and artistic means open up between the two poles formed by Caspar David Friedrich and Gerhard Richter, but also between Ercole de' Roberti and Gerhard Richter, and, by extension, between the beginnings of the autonomous easel painting in the 15th century and the carefully considered transformation of this tradition under contemporary conditions. Moreover, all the examples show that no nationally inherent art development characterized the genesis of the works by German artists selected here. On the contrary, the works were created within a network of European traditions and precursors—even if some of the artists under consideration consciously set out to create something individual, or something distinct from other dominant artistic directions.

Against this backdrop, the juxtaposition of paintings by Friedrich and Richter invites one to seek tensions, contrasts, commonalities, and the artist's intentions in these works as well as in the other pairings throughout the galleries. Furthermore, this experience can be accompanied by a satisfying emotion: "Schaulust," or the pleasure of vision.

Notes

1 In this regard see the text by Ulrich Bischoff in this volume.

2 As an important critical position see: Hofmann, Werner: *Wie deutsch ist die deutsche Kunst? Eine Streitschrift*, Leipzig 1999. See in general Locher, Hubert, *Deutsche Malerei im 19. Jahrhundert*, Darmstadt 2005, p. 9.

3 See Locher: *Deutsche Malerei,* op. cit., pp. 9–15.

4 See Alpers, Svetlana: *The Making of Rubens*, New Haven / London 1995, p. 99.

5 See especially the series of exhibitions *Zu Gast in der Galerie Neue Meister* [On Sojourn at the Galerie Neue Meister], as documented in a series of catalogues; see for example: Bischoff, Ulrich (ed.): *Sean Scully zu Gast in der Galerie Neue Meister*, exh.cat. Staatliche Kunstsammlungen Dresden, Galerie Neue Meister, Dresden.

6 Lindner, Gerd: "Sinnbilder wider das Vergessen. On Werner Tübke's *Lebenserinnerungen des Dr. jur. Schulze*," in: Tübke-Schellenberger, Brigitte and Gerd Lindner (eds.): *Werner Tübke. Das malerische Werk. Verzeichnis der Gemälde 1976 bis 1999*, exh. cat. Bad Frankenhausen, Dresden 1999, pp. 23–28, here: p. 25 .

7 The dating follows Manca, Joseph: *The Art of Ercole de' Roberti*, Cambridge 1992, p. 35.

8 Ibid.

9 Manca: *The Art of Ercole de' Roberti* (note 7), pp. 7, 35, 103.

10 Lindner: Sinnbilder (note 6), p. 24.

11 Beaucamp, Eduard: "Am Ende der Moderne: Eine Potenzierung der Kunst," in: *Werner Tübke* (note 6), pp. 281–290, here: p. 285.

12 See, e.g., Rathe, Kurt: *Die Ausdrucksfunktion extrem verkürzter Figuren*, London 1938 (Studies of the Warburg Institute; Vol. 8), p. 9.

13 Beaucamp: Am Ende der Moderne (note 11), p. 285.

14 Lomazzo, Gianpaolo: *Scritti sulle arti*, Ciardi, Roberto Paolo (ed.), Vol. 2: *Trattato dell'arte della pittura, scoltura et architettura*, Florence 1974, p. 317.

15 After Beaucamp: Am Ende der Moderne (note 11), p. 282.

16 Manca: *The Art of Ercole de' Roberti* (note 7), p. 1.

17 Beaucamp: Am Ende der Moderne (note 11), p. 286f.

18 Börsch-Supan, Helmut and Karl Wilhelm Jähnig: *Caspar David Friedrich. Gemälde, Druckgraphik und bildmäßige Zeichnungen*, Munich 1973, p. 435 (cat. no. 407).

19 See, e.g., Butin, Hubertus: "Gerhard Richter – Ein deutscher Romantiker?," in: *Gerhard Richter und die Romantik*, exh. cat. Kunstverein Ruhr, Essen 1994, pp. 7–28, here: pp. 17–19; Stückelberger, Johannes: "Mapping the Sky. Wolkenkartographie in der Meteorologie bei Gerhard Richter," in: *Wolkenbilder. Die Erfindung des Himmels*, exh. cat. Aargauer Kunsthaus Aarau, Aarau 2005, pp. 163–169.

20 Spitzer, Gerd: "Ludwig Richter – Der Maler," in: Spitzer, Gerd and Ulrich Bischoff (eds.): *Ludwig Richter – Der Maler*, exh. cat. Staatliche Kunstsammlungen Dresden, Galerie Neue Meister, Munich / Berlin 2003, pp. 13–43, here: pp. 17–21.

21 Letter from Richter to Wiegand from the 1850s, quoted from Spitzer ibid., p. 17.

22 Neidhardt, Hans Joachim: "Ludwig Richter und die romantische Landschaftsmalerei in Rom um 1825," in: Richter, Ludwig (note 20), pp. 54–63.

23 Richter, Ludwig: *Lebenserinnerungen eines deutschen Malers*, Leipzig 1909; Diary entries in appendix: Entry for 1830: Gedanken über Landschaftsmalerei, p. 574. See other entries, e.g., of Nov. 26, 1824, p. 517, re. Bellini's and Titian's *Bacchanal*: p. 522.

24 Spitzer, Gerd [catalog text], in: Richter, Ludwig (note 20), pp. 221–222.

25 Regarding the paintings see Allen, Denise and David Jaffé: "Poussin's *A Calm* and *A Storm*," in: *Apollo*, Vol. CXLVII, No. 436 (June), 1998, pp. 28–34, here: p. 28f.

26 Ibid., p. 29f.

27 See, e.g., McTighe, Sheila: *Nicolas Poussin's Landscape Allegories*, Cambridge / New York 1996, p. 37f.

28 Ibid., and also Blunt, Anthony (ed.): *Nicolas Poussin: Lettres et propos sur l'art*, Paris 1989, p. 141 (letter of June 22, 1648).

29 In regard to this motif see Spitzer, Ludwig Richter (note 20), p. 26f.

30 Richter, Ludwig: Lebenserinnerungen (note 23), p. 574: "Another, more symbolic tendency can be found in the landscapes of Titian, Nic. Poussin, Ruisdael, Everdingen, Friedrich, Koch…"

31 As per Richter in his Meissen notes of 1820; see Spitzer, Ludwig Richter (note 20), p. 20.

32 Echinger-Maurach, Claudia: "Michelangelo und Rubens erinnern sich an Schöpfungen Fra Bartolommeos," in: Dombrowski, Damian et.al. (ed.): *Zwischen den Welten. Beiträge zur Kunstgeschichte für Jürg Meyer zur Capellen*, Weimar 2001, pp. 78–91, here: pp. 78, 80f. (also in regard to the Getty painting).

33 See in general: Hollein, Max and Christa Steinle (eds.): *Religion. Macht. Kunst. Die Nazarener*, exh. cat. Schirn Kunsthalle Frankfurt, Cologne 2005, p. 179ff.

34 Franklin, David: *Painting in Renaissance Florence 1500–1550*, New Haven / London 2001, p. 83f.

35 Prause, Marianne: *Carl Gustav Carus. Leben und Werk*. Berlin 1968, p. 12f.

36 Carus, Carl Gustav: *Neun Briefe über Landschaftsmalerei. Geschrieben in den Jahren 1815 bis 1824*, Dresden, undated, p. 102 (5th letter).

37 See in general: Westheider, Ortrud: "Der hohe Himmel der niederländischen Landschaftsmalerei," in: *Wolkenbilder. Die Entdeckung des Himmels*, exh.cat. Bucerius Kunst Forum / Jenisch Haus, Hamburg, Hamburg 2004, p. 38.

38 Busch, Werner: *Joseph Wright of Derby. Das Experiment mit der Luftpumpe. Eine Heilige Allianz zwischen Wissenschaft und Religion*, Frankfurt/M. 1986, pp. 7–11.

39 Nicolson, Benedict: *Joseph Wright of Derby. Painter of Light*, London 1968 (Studies in British Art), Vol. 1, p. 71f.

40 See Kluxen, Andrea M.: *Das Ende des Standesporträts. Die Bedeutung der englischen Malerei für das deutsche Porträt 1760–1848*, Munich 1989.

41 Nørregard-Nielsen, Hans Edvard: *Christen Købke*, Vol. 3, Copenhagen 1996, p. 129 (fig. 108), p. 141ff.

42 See, e.g., Börsch-Supan, Helmut, in: Schuster, Peter-Klaus (ed.): *Carl Blechen. Zwischen Romantik und Realismus*, exh.cat. Nationalgalerie Berlin, Munich 1990, p. 106, cat. no. 107.

43 Richter-Musso, Inés: "Die Wolke als Lehrmeisterin der Malerei in Rom um 1800. Das Vermächtnis Valenciennes," in: *Wolkenbilder. Die Entdeckung* (note 37), pp. 48–55 (on Denis see p. 52f.).

44 After Spitzer, Gerd: *Christian Friedrich Gille, 1805–1899*, exh.cat. Staatliche Kunstsammlungen Dresden, Galerie Neue Meister, Leipzig 1994, p. 25.

45 Richter, Ludwig: Lebenserinnerungen (note 23), p. 176f.

46 On the genesis and importance of Gille's oil sketches see Spitzer, Gerd: Gille (note 44), pp. 18–26.

47 Andree, Rolf: *Arnold Böcklin. Die Gemälde*,

Basel/Munich 1998, p. 432–433.

48 On the criteria of the idyll see, for example, Jensen, Jens Christian: "Die italienische Landschaft als idealer Ort der klassizistischen Idylle," in: Wedewer, Klaus and Jens Christian Jensen (eds.): *Die Idylle: eine Bildform im Wandel zwischen Hoffnung und Wirklichkeit; 1750–1930*, Cologne 1986, pp. 137–141, here: p. 137.

49 Zelger, Franz: *Arnold Böcklin. Die Toteninsel. Selbstheroisierung und Abgesang der abendländischen Kultur*, Frankfurt/M. 1991, p. 8.

50 Zelger, Franz (ibid., p. 44) connects the Rousseauian island with the pictorial concept for *Isle of the Dead*; in the *Summer Day*, Böcklin could also have recalled the motif.

51 Schemm, Jürgen von: "Edvard Munch und Arnold Böcklin," in: *Edvard Munch*, exh. cat. Folkwang Museum Essen 1987/Kunsthaus Zürich 1988, pp. 44–47, here: p. 44.

52 Hansen, Dorothee: "Bilder der Empfindung. Munch und die deutsche Malerei im späten 19. Jahrhundert," in: *Munch und Deutschland*, exh. cat. Hypo-Kulturstiftung Munich/Hamburger Kunsthalle/Nationalgalerie Berlin, Stuttgart 1994, pp. 142–144, here: p. 142f.

53 See Pastor, Willy, in: Przybyszewski, Stanislaw (ed.): *Das Werk des Edvard Munch*. Vier Beiträge von Stanislaw Przybyszewski, Dr. Franz Servaes, Willy Pastor, Julius Meier-Graefe, Berlin 1894, pp. 57–74.

54 Schremm, Jürgen, in: Edvard Munch und Arnold Böcklin (note 51), p. 128.

55 Hansen: Bilder (note 52), p. 143.

56 Locher: *Deutsche Malerei* (note 2), p. 166f.

57 Frenssen, Birte: "Der Parademarsch des Malers. Die Bildnisse," in: *Max Liebermann. Der Realist und die Phantasie*, exh. cat. Hamburger Kunsthalle, Hamburg 1997, pp. 199–203, here: p. 199.

58 Schulz-Hoffmann, Carla: "Corinth und die Moderne," in: *Lovis Corinth*, (ed.) Schuster, Peter-Klaus, Christoph Vitali and Barbara Butts, exh. cat., Berlin/Munich 1996, pp. 87–95, here: p. 87ff., p. 90.

59 Swanson, Vern Grosvenor: *John William Godward. The Eclipse of Classicism*, Woodbridge 1997, p. 22.

60 See re. J. Paul Getty's collection: Jaffé, David: Introduction, in: Jaffé, David: *Summary Catalogue of European Paintings in the J. Paul Getty Museum*, Los Angeles 1997, pp. IX–XVII, here: p. X.

61 Dalbajewa, Birgit and Ulrich Bischoff (eds.): *Die Brücke in Dresden 1905–1911*, exh. cat. Staatliche Kunstsammlungen Dresden, Galerie Neue Meister, Cologne 2002, p. 41ff., 97ff. and elsewhere.

62 He also painted other versions of this street scene. Farr, Dennis: "Edouard Manet's *La Rue Mosnier aux Drapeaux*," in: Wilmerding, John (ed.): *Essays in Honor of Paul Mellon, Collector and Benefactor*, National Gallery of Art, Washington, Hanover/London 1986, pp. 97–109, here: 97.

63 Kasl, Ronda: "Edouard Manet's *Rue Mosnier*: Le pauvre a-t-il une patrie?," in: *Art Journal*, Vol. 44, No. 1 (1985), pp. 49–59.

64 Shackelford, George T. M. and Claire Frèches-Thory: *Gauguin, Tahiti. The Studio of the South Seas*, exh. cat. Galeries Nationales du Grand Palais, Paris/Museum of Fine Arts, Boston, Boston 2004, p. 106.

Paintings from the Galerie Neue Meister at the J. Paul Getty Museum

Caspar David Friedrich

1774 Greifswald – 1840 Dresden

Cross in the Mountains (Tetschen Altar) 1807/08

Das Kreuz im Gebirge (Tetschener Altar)
Oil on canvas, 115 × 110 cm
Acquired in 1921 from Count Franz of Thun and Hohenstein, Tetschen
Galerie Neue Meister, Staatliche Kunstsammlungen (Gal. Nr. 2197 D)
Lit.: Börsch-Supan/Jähnig: Catalogue Raisonné no. 167

Friedrich, the outstanding master of early German Romanticism, was an avant-garde artist in his time to a degree that one can hardly imagine today. The so-called *Tetschen Altar* is Friedrich's programmatic masterpiece from his early period, and it marks his decisive break with the traditional rules and conventions of art. The awakening of early Romantic painting at the beginning of the 19th century was not a gradual change in taste, but an artistic revolution with radical consequences. Created from a pen-and-ink drawing that he had already exhibited in 1807, Friedrich presented the unusual painting to the public in an equally unusual manner upon its completion at the end of 1808. According to a contemporary report, Friedrich briefly presented the work to the public at Christmas in his studio (although the artist himself was away at the time), creating a great sensation. The painting was displayed on a black-draped table, in a darkened room lit only by artificial light. This first public presentation provoked an intense controversy that became known as the "Ramdohr dispute," which made the artist and his work famous. An essay by Chamberlain Friedrich Wilhelm Basilius von Ramdohr, which appeared in January 1809 in the *Zeitschrift für die elegante Welt*, sharply attacked the painting. Questioning the work's basic justification, the article triggered a debate, in the course of which some of the painter's friends and the painter himself stated their positions publicly. A main point of attack was the transgression of established genre boundaries. A landscape painting, intellectually condensed and formally highly concentrated, had been raised to the status of a devotional painting. In answer to Ramdohr, Friedrich felt compelled to give an interpretation of the picture himself, and this statement became a fundamental model for attempts at explaining his other symbols. According to Friedrich, the rock with the erected crucifix can be interpreted as a symbol for the firmness of faith. The evergreen spruces, "through the ages," surround the cross "like our own hope in him, the crucified one." Friedrich originally intended the painting for the Swedish king and opponent of Napoleon, Gustav IV Adolf of Sweden, and thus its meaning was associated with patriotic content. Before its completion in 1808, however, the Count of Thun and Hohenstein acquired it for his castle in Tetschen, setting it up in private chambers. It was never used as an altar painting in the chapel, however, although the frame, made according to Friedrich's design by Christian Gottlieb Kühn, emphasized its sacred intention and gave the painting itself its full effect.

GERD SPITZER

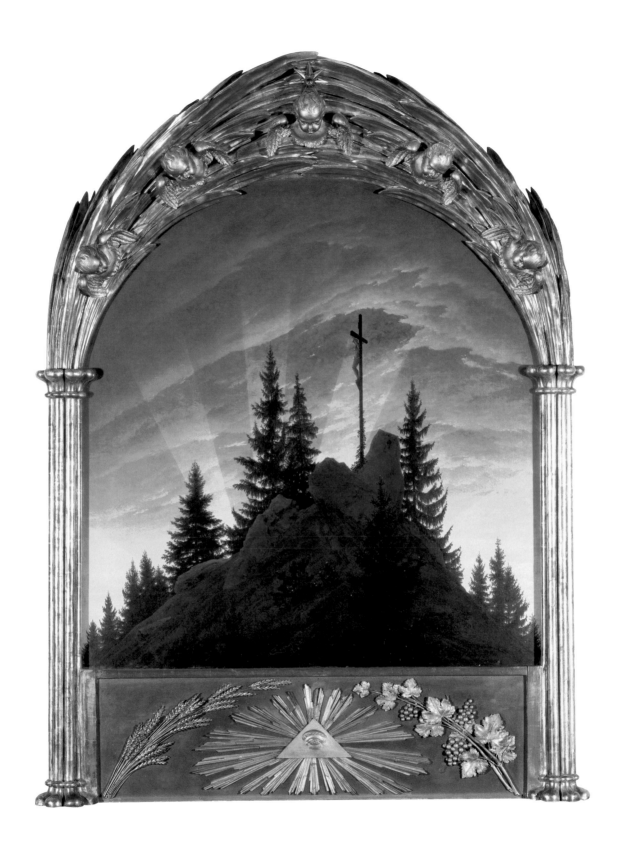

Caspar David Friedrich

1774 Greifswald – 1840 Dresden

Dolmen in the Snow 1807

Hünengrab im Schnee
Oil on canvas, 61 × 80 cm
Acquired in 1905 from Catharina Dahl, Dresden
Galerie Neue Meister, Staatliche Kunstsammlungen Dresden (Gal. Nr. 2196)
Lit.: Börsch-Supan/Jähnig: Catalogue Raisonné no. 162

Under the influence of Friedrich, who was born in North Germany and came to settle in the city on the Elbe River in 1798, Dresden became a center of early German Romantic art. One of the earliest works among the 14 paintings by Friedrich in the Galerie Neue Meister, where his work forms the core of an internationally renowned collection of Romantic art, is *Dolmen in the Snow*. When he painted this work, Friedrich had only just begun painting intensively in oil.

Against the icy blue background in the diminishing light of the day, a plane in the foreground of the image advances very close to the viewer's vantage point, almost like a filigreed silhouette. The symbolic language of Friedrich's landscapes takes its vocabulary from studying nature, and it is based on the meditative internalization of his sensory experiences. This virtually universal picture of winter with the heathen tomb surrounded by oaks in the middle of nature—still and frozen, but eagerly awaiting the awakening of spring—could equally well suggest allusions to the awakening of Christian faith, or to a new "nationalistic" consciousness in an anti-Napoleonic spirit. This stone monument from a very early period of Germanic history and familiar to the artist as a motif from his North German homeland and the ancient oak trees withstanding the adverse storms of time, can be seen both as symbols of a heroic national past, and in terms of a patriotic renewal under threatening political conditions. The artist often used drawings from his sketchbooks for the details of his compositions, and here Friedrich based the composition of this painting entirely on detailed individual studies from nature. Friedrich himself once referred to the winter snow, completely covering the hill in the painting, as "that large white cloth, the perfect example of absolute purity, beneath which nature prepares herself for a new life...." In the same context, the artist also said, "Truly every appearance within nature, grasped correctly, worthily and aptly, can become a subject of art."

GERD SPITZER

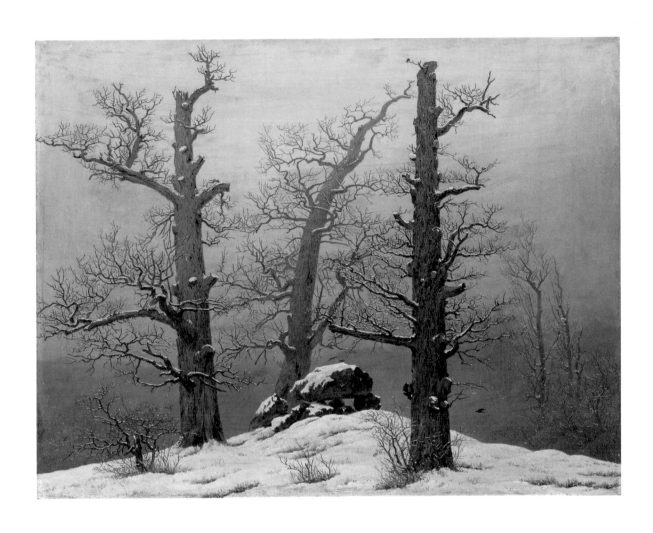

Caspar David Friedrich

1774 Greifswald – 1840 Dresden

View of the Elbe Valley 1807

Ausblick ins Elbtal
Oil on canvas, 61.5 × 80 cm
Acquired in 1932 as a gift of the Dresdner Museumsverein
Galerie Neue Meister, Staatliche Kunstsammlungen Dresden (Gal. Nr. 2197 F)
Lit.: Börsch-Supan/Jähnig: Catalogue Raisonné no. 163

Friedrich produced this painting around the same time as *Dolmen in the Snow* (p. 37). He often conceived his pictures, particularly in this early period, as interrelated, and so the summery *View of the Elbe Valley* can be seen as a pendant to the winter scene of *Dolmen in the Snow*, which closely corresponds to it in terms of its size, as well as its pictorial concept and symbolic content. Allegorical thoughts about human life and death, in terms of commonly held notions of Christian faith, find a vivid depiction in the juxtaposition of winter and summer, using the context and pictorial symbols of studiously reproduced nature. Thus the evergreen spruces on the rocky slope above the steadily flowing river have a special relationship to the bleak, frozen oak trees and the prehistoric tomb. Friedrich allegorically juxtaposes a pre-Christian heathen past with the Christian philosophy of life. His distilled pictorial language is decidedly oriented towards the intellect; accordingly he selects only the essential elements. Another basic compositional principle is the intellectual tension between the closely viewed, sharply focused foreground silhouette, and the almost transitionless "beyond," an incalculably remote and distant space. In its motifs and form the composition of the landscape is closely related to his famous masterpiece *Cross in the Mountains* of 1807/08 (p. 35), which it also resembles in its handling and palette. Compared with *Cross in the Mountains*, the spruces above the rocky slope could also be interpreted as a symbol of the deeply rooted Christian faith of mankind. A number of specific locations for the view across the wide river valley have previously been suggested. However, even though certain landscapes the painter had seen in the Elbe valley in Bohemia might have served as an inspiration, Friedrich invented his own composition.

GERD SPITZER

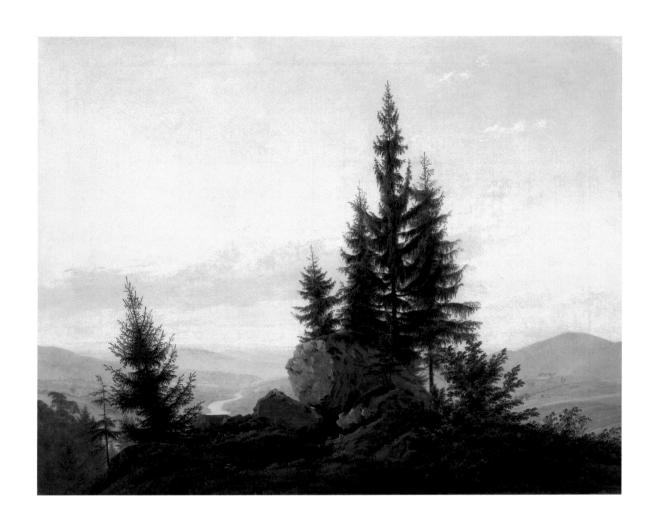

Caspar David Friedrich

1774 Greifswald – 1840 Dresden

Bohemian Landscape with Milleschauer Mountain 1808

Böhmische Landschaft mit dem Milleschauer
Oil on canvas, 70 × 104 cm
Acquired in 1921 from Count Franz of Thun and Hohenstein, Tetschen
Galerie Neue Meister, Staatliche Kunstsammlungen Dresden (Gal. Nr. 2197 E)
Lit.: Börsch-Supan/Jähnig: Catalogue Raisonné no. 188

Until 1921 the owner of this painting, as well as another almost identically sized "Bohemian landscape," was Count Franz of Thun and Hohenstein. Both paintings had been located in his castle, Schloss Tetschen on the Elbe River, where Friedrich's programmatic masterpiece *Cross in the Mountains* (*Tetschen Altar*, p. 35) had also been kept for more than a century. In the spring of 1921, all three works were put up for sale through art dealers in Berlin and Munich. The Gemäldegalerie in Dresden secured the option of purchasing all three paintings, but the unusual acquisition was a great financial strain. Thus, the museum's first choice, the *Cross in the Mountains*, and the painting under discussion here, showing the Bohemian landscape in the morning mist, were purchased. Its counterpart depicting a scene from the same area, but during the evening, was acquired by the Staatsgalerie Stuttgart, where it remains today, and so the pendants have been separated for 85 years. Friedrich created both paintings in 1808 as a commission of Count Franz Anton of Thun and Hohenstein, who acquired Friedrich's *Cross in the Mountains* at that time. The patron married the Countess of Brühl on September 5 of the same year. Recent scholarship has related the pendants of morning and evening to this marriage as a pair of "wedding pictures," alluding to the journey through life on which the bridal couple was to embark.

The focus on human life on earth in this work is stronger than usual for Friedrich. The landscape depicts low mountain ranges in Bohemia south of Teplitz. Our gaze goes to the right towards Milleschauer Mountain. On the left, symmetrically balancing the composition, the profile of a second peak, the Kletschen, rises to the same elevation. From the blue-gray, distant silhouette our eye then returns to the lush green sloping meadow in the foreground, wandering down the path into the valley, to the flat, crouching house half hidden in trees and bushes, the smoke climbing from the chimney betraying the presence of human life. We can imagine ourselves climbing the path on the right into the hills, with the ever-lighter yellowish-green of their heights, seeking a better view of this landscape from there. The ease with which our eyes stroll along the path offered in the painting's foreground seems to correspond to a mental state: it perfectly matches the character of Friedrich's depiction of nature. In its wonderful tenderness and cheerful detachment, this painting is undoubtedly one of the most beautiful depictions of landscape in German painting.

GERD SPITZER

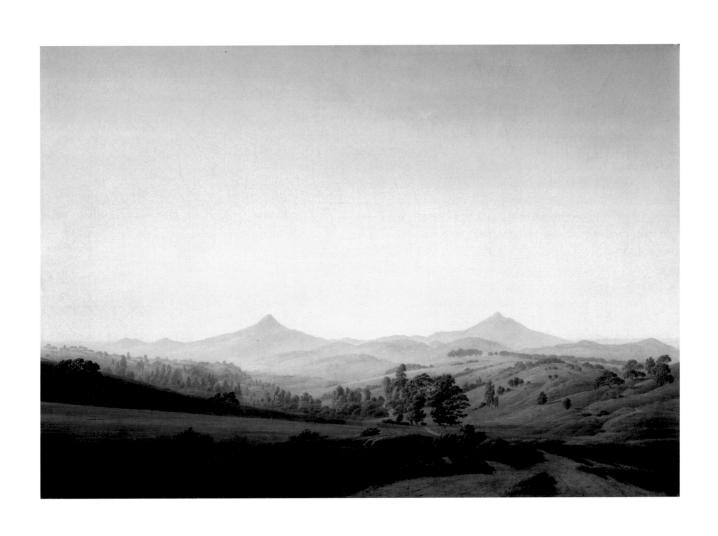

Caspar David Friedrich

1774 Greifswald – 1840 Dresden

Dolmen in Autumn ca. 1820

Hünengrab im Herbst
Oil on canvas, 55 × 71 cm
Donated in 1868 by the Dresden Art Academy
Galerie Neue Meister, Staatliche Kunstsammlungen Dresden (Gal. Nr. 2195)
Lit.: Börsch-Supan/Jähnig: Catalogue Raisonné no. 271

In 1816 Friedrich was appointed as a member of the Art Academy in Dresden. In this context he was obliged to submit a reception piece to the Art Academy, which remained in the property of the institution. As shown by a letter of reminder of January 12, 1819, however, the artist initially failed to fulfill this obligation. The painting might have been created and delivered soon thereafter, however, for when Friedrich was appointed as an associate professor of the Art Academy in January 1824 the unfulfilled obligation was no longer mentioned. In 1835 the painting appeared for the first time in a register of accessions of the academy under the title *Landscape with Monolithic Tomb in an Advancing Thunderstorm*. In 1868 it was donated by the Art Academy to the Gemäldegalerie, which had previously possessed only two paintings by Friedrich, acquired through his friend Johan Christian Dahl in 1840 after the artist's death. Indeed, until the early 20th century, Dresden's holdings of only three paintings by Caspar David Friedrich, was rather small.

Also in this composition Friedrich used his studies drawn from nature for important pictorial elements such as the monolithic tomb, the shattered tree stump, the branches lying on the ground, and individual plants. Here, he combined these studies into an unusually dramatic pictorial invention. If monolithic tombs in Friedrich's pictorial language are seen not only as symbols of the transience of life, but also as lasting memorials to a grandly heroic past, then this monument to patriotic reflection seems eminently threatened by elemental forces. The storm, ominously raging across the land with the force of a natural disaster, has even broken the oak, and its splintered, ruptured stump rises against the darkened sky. Only the powerful boulder resists the furious thunderstorm, appearing like an immovable bulwark in natural surroundings otherwise gripped by tremendous turbulence.

GERD SPITZER

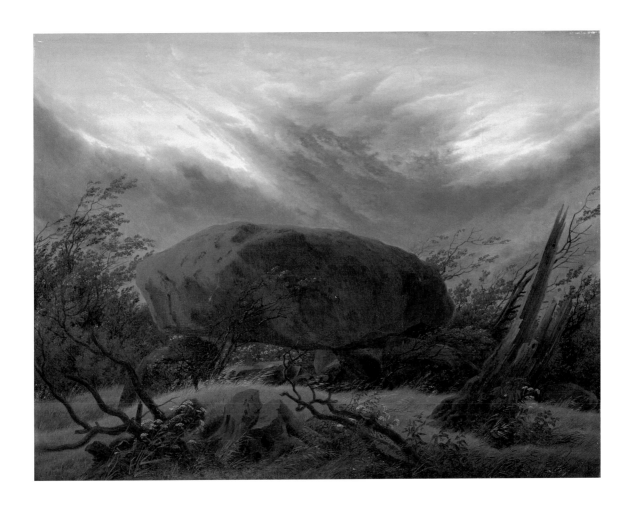

Caspar David Friedrich

1774 Greifswald – 1840 Dresden

Two Men Contemplating the Moon ca. 1819

Zwei Männer in Betrachtung des Mondes
Oil on canvas, 33 × 44.5 cm
Acquired in 1840 from Johan Christian Dahl, Dresden
Galerie Neue Meister, Staatliche Kunstsammlungen Dresden (Gal. Nr. 2194 E)
Lit.: Börsch-Supan/Jähnig: Catalogue Raisonné no. 261

This relatively small painting is not just one of Friedrich's best-known works in Dresden, but it also shows with remarkable clarity the painter's personal way of depicting a profound contemplation of nature and the world in his landscapes. Two men, clearly well-acquainted with one another, are lost in thought as they surrender themselves to the sight of the night sky, with the crescent moon and evening star in an ever-widening space that stretches into an immeasurable distance. Standing in the foreground as figures seen from the rear, these men offer their point of view to the viewer's own gaze, thus acting as perceptual stand-in for the viewer's own feelings and experiences. This tension may be interpreted as an expression of the high degree of metaphorical abstractive potential inherent in this way of looking at nature that has become the very subject of the picture here. According to tradition, Friedrich depicted himself together with his favorite student, August Heinrich, in this allegory of contemplative absorption and friendly devotion. The stony path, which the two men have ascended, alludes to the path of life; the dead oak, a symbol of death, contrasts with the evergreen fir; and the waxing moon acts as a symbol of hope. The historicizing, *altdeutsch* [Old German] dress of the two figures in the picture, with their broad capes and hats, as well as Friedrich's ironic statement, "They are engaged in demagogic activities," suggests an interpretation of the painting as a patriotic and oppositional statement during the oppressive period of restoration after the Napoleonic Wars and the persecution of "demagogues." In his essential research on Friedrich, Werner Busch pointed out that among all the interpretive models for this painting (and for Friedrich more generally), models that are not at all mutually exclusive, far too little attention has been paid to aesthetic organization. Nonetheless he argues in detail that only "through the aesthetic measurement system of origin and goal" are "the paintings' deeper meanings denoted." (Werner Busch) After Friedrich's death in 1840 this painting was acquired by the Dresden museum from the artist's friend Johan Christian Dahl. It was one of that museum's first two works by Friedrich, and there it has "remained a type of signature image of German Romanticism to this day."

<div style="text-align: right">GERD SPITZER</div>

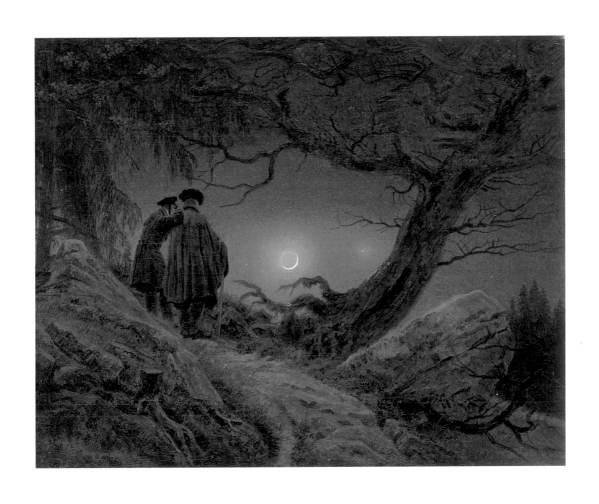

Caspar David Friedrich

1774 Greifswald – 1840 Dresden

Bushes in the Snow 1827/28

Gebüsch im Schnee
Oil on canvas, 31 × 25.5 cm
Acquired in 1921 from the art dealer H. Kühl, Dresden
Galerie Neue Meister, Staatliche Kunstsammlungen Dresden (Gal. Nr. 2197 G)
Lit.: Börsch-Supan/Jähnig: Catalogue Raisonné no. 359

Friedrich enlarged this small piece of nature, seen from a very close vantage point, to fill the canvas. Yet in this case, he did not intend the deliberately concentrated view simply to be a study from nature, nor did he only want to reproduce, in a detailed manner faithful to the original, something he had seen. The leafless tangle of branches at first appears disordered and random, but upon closer inspection, the carefully accentuated and constructed growth and the filigreed pattern of the whole become obvious. Like an impenetrable barrier, the alder bushes flatly stand out against the gray winter sky. The branches obstruct the transition between the narrow, clearly articulated strip of foreground, which establishes the viewer's perceptual position, and the diffuse and incalculable background space. Bringing us towards the painting's deeper meaning is the obvious correspondence with Friedrich's closely related painting of roughly the same size, *Fir Trees in the Snow*, located today in the Neue Pinakothek in Munich. Even in 1828 in the first exhibition where they were shown together, the two works were described as pendants. Their previous title, which was still used around 1900, *From the Dresden Heath I* and *II*, also testifies to their close connection. If evergreens trees in the snow can be interpreted as symbolic of the Christian faith's confident belief in resurrection, then the young alders' snowy bare branches can be associated with the expectations of spring, as well as with a hope for the reawakening of all life. A contemporary reviewer, using these counterparts as his example when they were presented at the Leipzig Easter Fair in 1828, aptly described the principle of Friedrich's perception of nature: "From Professor Friedrich in Dresden we see two little pictures. This sensible painter likes to devote himself to the inclination to give independent significance to things which appears less important in the usual view of nature, or as a component of something else, thus often *putting this significance in*."

GERD SPITZER

Caspar David Friedrich

1774 Greifswald – 1840 Dresden

Evening on the Baltic Shore 1831

Abend am Ostseestrand
Oil on canvas, 54 × 72 cm
Acquired in 1920 from Ida von Mayer, Moritzburg, near Dresden
Galerie Neue Meister, Staatliche Kunstsammlungen Dresden (Gal. Nr. 2197 C)
Lit.: Börsch-Supan/Jähnig: Catalogue Raisonné no. 391

Ships docked at the seashore and sailing out onto the open sea, a familiar sight since childhood to Friedrich, who had been born on the Baltic coast, were among the painter's favorite subjects. In a parallel to the symbolic character of his landscape paintings, parables of human life likewise form an intrinsic part of the painter's seascapes. Sailboats leave the protective shelter of the port on their dangerous "journey of life," finally to return at the end of the voyage to their harbor of origin. According to Helmut Börsch-Supan, the section of coast depicted in the painting resembles the Bay of Greifswald at the mouth of the river Ryck, into which a boat is just sailing on its way to harbor. A peaceful evening atmosphere pervades the scene. It is enhanced by the coolly muted moonlight, illuminating the broad night sky like an imaginary light source, glittering on the calm sea, combined with the warmer but comparatively insignificant light of the small fire tended by the two fishermen on the shore. In many of Friedrich's pictorial compositions, figures are seen from behind gazing out into the remote distance and represent the viewpoint and feelings of the viewer. But the two men here, screened from the more distant space by hanging nets, face the painting's viewers and are positioned exactly below the incoming sailboat, which flies the Swedish flag. Also striking is the large anchor, a symbol of hope, lying beside them on the bank.

Although this painting was exhibited in 1831 at the Dresden Art Academy exhibition under the title *Seashore, Moonlight,* and reproduced the same year in the *Bilderchronik* published by the Sächsischer Kunstverein, it was initially attributed to the "school of C. D. Friedrich" after its acquisition by the Gemäldegalerie in 1920. Through the discovery of the *Bilderchronik* illustration from Carl Peschek the work could be shown as Friederich's own. This led to a legal dispute with the painting's previous owner in 1928/29. Her grandfather had acquired the painting in 1831 at a raffle of the Sächsischer Kunstverein, but the details about the work in the family's possession had clearly been lost over time. The great interest in Friedrich since his rediscovery at the beginning of the 20th century, however, had led not only to a growing appreciation of the painter, but also to a considerable increase in the estimated value of his works.

GERD SPITZER

Julius Schnorr von Carolsfeld

1794 Leipzig – 1872 Dresden

The Family of Saint John the Baptist Visiting the Family of Christ 1817

Die Familie Johannes des Täufers bei der Familie Christi
Signed lower right: JS (monogram) 1817
Oil on canvas, 123 × 102.5 cm
Acquired in 1868 from the estate of Johann Gottlob von Quandt
Galerie Neue Meister, Staatliche Kunstsammlungen Dresden (Gal. Nr. 2217)
Lit.: Teichmann: Catalogue Raisonné no. 4

The Nazarene Schnorr von Carolsfeld became known primarily for his excellent drafts-manship, his large murals, and his biblical illustrations. His painted œuvre, on the other hand, comprises hardly more than three dozen oil paintings. Born in Leipzig in 1794, as the son of Hans Veit Schnorr von Carolsfeld, who would later become director of the Leipzig Art Academy, the young man entered the Art Academy in Vienna in 1811. In 1817, he traveled through Venice and Florence to Rome, where he joined the circle around the Brothers of St. Luke, and grew to be a leading figure in the Nazarene movement. In 1827 he accepted a call to go to Munich and was kept there for decades by many mural commissions from Ludwig I. After his summons to Dresden in 1846, he exercised considerable influence on artistic life in the city as professor at the Art Academy and director of the Gemälde-galerie.

Schnorr created this work in the last years of his stay in Vienna. At that time he lived in the house of his friend, the artist Ferdinand Olivier, who had provoked Schnorr's interest in early German painting. Before his departure for Italy, Schnorr sent the completed work back to Saxony, where it was exhibited as early as 1817. In letters to his father, Schnorr con-fided his motivation for creating this painting, as well as some uncertainty in judging his own early works. According to these letters, he had freely chosen the subject and composed it as a picture of great intimacy: "I concentrated into a single focus that which had filled me for a long time, as best I could; often more than I had at my command appeared there… Into the Holy Family I projected my entire joy, which through my acquaintanceship with the Elector (and precisely those holy figures), I had in my spirit from my first visit." This heartfelt remark conveys the earnestness of Nazarene artistic efforts.

Shown in the picture is the visit, described in apocryphal sources, of Zachary and Eliza-beth—parents of John the Baptist—to the Christ child, Mary, and Joseph. The painter evocatively echoes the medieval iconography of the Madonna of the Rose Bush and the *Paradiesgärtlein*. The rigorously composed image of pious absorption was in the service of the current trend toward the internalization of religious convictions, expressed by the painting's clarity and purity of expression. Taking recourse to the pictorial motifs and sty-listic idiom of German medieval and Renaissance art, this early work by the young artist is an excellent example of how artists reformulated devotional pictures in the Nazarene spirit. Schnorr prepared the composition carefully over two years, producing two draw-ings, numerous studies of details, and a preparatory work on cardboard. In 1868 the paint-ing was acquired from the estate of the Dresden art collector Johann Gottlob von Quandt for the Dresden Gemäldegalerie, still under the directorship of Schnorr himself.

GERD SPITZER

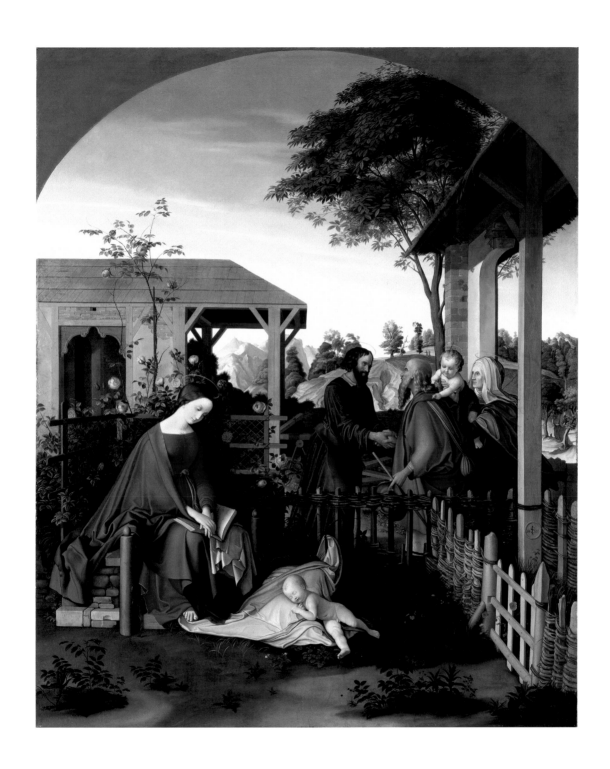

Carl Blechen

1798 Cottbus – 1840 Berlin

Ruins of a Gothic Church 1826

Gotische Kirchenruine
Oil on canvas, 129.5 × 96.5 cm
Acquired in 1931 from a private collection in Berlin
Galerie Neue Meister, Staatliche Kunstsammlungen Dresden (Gal. Nr. 2637 A)
Lit.: Rave: Catalogue Raisonné no. 172

The painter's relatively high vantage point gives the viewer a glimpse into a dilapidated Gothic cathedral, yet without affording a clear overall view. Unlike medieval sacred buildings in which transparency and brightness indicated the presence of the divine, Blechen's glimpse of the ruined church conveys chaos and decline among the horrific abysses. Although the lighting—through the windows and the church's collapsed roof—allows for dramatic, theatrical effects, it also draws upon the illumination of Gothic cathedral architecture. On the other hand this use of light downplays central areas of the paintings, and plays up hidden corners: the sleeping pilgrim and two sarcophagi appear beside a mighty pillar on the church floor, overgrown with moss. Nearby, a young, brightly lit birch tree grows wild and rises into the sky. The broken down arches allow an escape from the darkness of the crypt.

Three years before creating the painting Blechen had travelled with Johan Christian Dahl, whom he greatly admired, from Dresden to Meissen to study the cathedral and Albrechtsburg castle in detail. A group of twelve drawings, none of which are classically composed, demonstrates his interest in unconventional views. Blechen clearly draws on the knowledge he acquired from viewing the Meissen buildings for the Dresden painting. In his composition, however, Blechen playfully varied the conventions of architecture by interchanging the plans of basilica and hall church, transept and nave. In general, Blechen adopts an extremely free method of dealing with architectural details, which may have been prompted by memories of the ruined Cloister of Oybin, which he had visited in 1822.

The architecture subjected to the effects of nature recalls the forest imagery that plays a prominent role in Blechen's visual world. The young pilgrim with the girlish face dreams of a world in which this poetically imbued vegetation along with its ally, time, makes its altering incursions. In scenarios like these "the imagination sneers at the scheming orderliness of the bourgeois world" (Heino R. Möller), and Blechen's creative will finds expression as Romantic irony. The sleep at the edge of the precipice refers to *The Sleep of Reason Produces Monsters* by Goya and abruptly points out the modernity of Blechen, who remains underappreciated to this day.

ULRICH BISCHOFF

Christian Friedrich Gille

1805 Ballenstedt near the Hercynian Forest – 1899 Dresden

At the Weisseritz River in Plauen 1833

An der Weißeritz in Plauen

Signed lower left (scratched into the wet paint): Plauen am 14 Sep 33 CG 3-6¹/₄
At lower edge of card (in pencil): Von 3¹/₂ – 6¹/₄ 14. Sept. 33
Oil on paper, mounted on cardboard; 28 × 38.3 cm
Donated in 1937 by Johann Friedrich Lahmann, Dresden
Galerie Neue Meister, Staatliche Kunstsammlungen Dresden (Gal. Nr. 2233 P)

Gille, born in a small town near the Hercynian Forest, moved to Dresden in 1825 to study to be an engraver. There, he met the Norwegian landscape painter, Johan Christian Dahl, who was of decisive significance, and Gille became a student in Dahl's studio in 1827. Inspired by Dahl, Gille produced small oil sketches directly from nature, and their realism, considered sensationally new at that time, was thought to express clearly a true connection to reality with an impressively fluid painting style. Through his consistent preoccupation with this manner of viewing nature, over several decades and in hundreds of works, he developed a personal means of expression. Gille received very little recognition for these studies during his lifetime. Only after his death was he recognized as one of the most important 19th-century landscape painters from Dresden.

Gille lived and worked in Dresden and its rural surroundings for almost seven and a half decades, finding the unspectacular motifs for his painterly studies of nature largely in the hidden corners, suburbs, and villages near the city. On an early autumn afternoon in 1833, in the quiet village of Plauen (today a neighborhood in Dresden), he saw a laundress on the tree-lined shore of the Weisseritz River, and noted on the edge of the sheet the exact time and place of this optical experience. According to these notations, Gille worked on this small study for approximately three hours on the spot. From the foreground, the viewer's eye moves past the high trees across the rippling, reflecting surface of the water, beyond the old stone bridge, to the hills and the sky's low horizon in the background. The laundress's red skirt forms the crucial color accent in the picture's overall tone. Dapples of a lighter yellowish-green glow where the sun shines through the foliage. The dark brown-green shadows of the large cluster of trees beyond the shore stand out against the water. Gille records everything not only with a sober and observant emotional distance, but also with the eye of an observer whose senses have been stirred. The little landscape painting, on loan from the Dresden collector Johann Friedrich Lahmann, was exhibited in 1906 in the centennial exhibition at Berlin's Nationalgalerie. This legendary retrospective of German 19th-century art was not only where Caspar David Friedrich was rediscovered, but was also where Gille "first came to our attention," as Alfred Lichtwark, Director of the Hamburger Kunsthalle, remarked in 1909 after visiting Lahmann in Dresden. Lahmann, to whose generous bequest the work belongs, was the first person to have discovered Gille's outstanding individuality.

GERD SPITZER

Carl Gustav Carus

1789 Leipzig – 1869 Dresden

Oaks by the Sea (Memory of a Wooded Island on the Baltic Sea) 1835

Eichen am Meer (Erinnerung an eine bewaldete Insel der Ostsee)
Oil on canvas, 117.5 × 162 cm
Acquired in 1955 from a private collection in Dresden
Galerie Neue Meister, Staatliche Kunstsammlungen Dresden (Gal. Nr. 2905)
Lit.: Prause: Catalogue Raisonné no. 325

Physician, scholar, and writer, Carus was a universal spirit in the tradition of Johann Wolfgang von Goethe and Alexander von Humboldt. He was in fact an amateur artist, painting only as a secondary occupation. Yet he was still one of the most remarkable painters of his time. Born in Leipzig in 1789, Carus studied medicine, natural sciences, and philosophy in his birthplace and in 1814 was appointed Professor of Obstetrics at the Academy for Surgery and Medicine in Dresden. In 1827 he became one of the three personal physicians of the King of Saxony. With his book *Nine Letters on Landscape Painting* (begun in 1815 and first published in 1831), and his concept of the Art of Depicting Life on Earth [*Erdlebenbild Kunst*], Carus also contributed significantly to contemporary art theory.

Carus, who had been particularly influenced by 17th-century Dutch landscape painting early in his career, met Caspar David Friedrich shortly after participating for the first time in the Dresden Art Academy exhibition in 1816. Friedrich became his close friend and his artistic role model for some time. At Friedrich's suggestion, he undertook a trip to the Baltic Sea island of Rügen in August 1819, in order to understand Friedrich's art better through personal experience of his North German homeland. Only a decade and a half later he produced the unusually large painting in reminiscence of his experiences of this journey. On December 21, 1834, Carus wrote to his friend Gottlob Regis, "Even in these gray days I occasionally take an hour of my midday meal time to go to my painting room [...] to work on enormous oaks, which currently attract me the same way as would a rekindled early love." On his trip to Rügen, Carus had been particularly impressed by a visit to the small island of Vilm, southeast of Putbus, and was especially fascinated by its pristine character, far from civilization: "I can state that I have hardly ever since had a feeling of such a completely pure, beautiful, and lonely natural life, as back then on this island that nobody else cared to see when they visited Rügen. In what a painterly manner does the freshest vegetation of the undergrowth thrust itself over the rock piled upon the shore; how undisturbed and venerable are the oaks and beeches grown to unusual size. [...] In short, proliferate, abundant, primeval nature, wherever one looked. Later, in a larger painting, *Memory of a Wooded Island on the Baltic Sea*, I attempted to reproduce something of this scenery mentally..." In this work he set the recollected scale of his impression of nature against the landscape's quiet tranquility. Carus stylizes and stages his rendering of the ancient, storm-battered trees under a quickly changing sky to augment the composition's strong symbolic power.

GERD SPITZER

Johan Christian Dahl

1788 Bergen – 1857 Dresden

Dresden by Moonlight 1839

Blick auf Dresden bei Vollmondschein
Signed lower center: JDahl 1839
Oil on canvas, 78 × 130 cm
Acquired in 1937 from an art dealer in Berlin
Galerie Neue Meister, Staatliche Kunstsammlungen Dresden (Gal. Nr. 2206 D)
Lit.: Bang: Catalogue Raisonné no. 886

Born in Bergen in Norway, Dahl initially came to Dresden in 1818 during a long study trip following his artistic education at the Copenhagen Art Academy. He settled in Dresden permanently and soon befriended Caspar David Friedrich, with both men even living in the same building on the banks of the Elbe after 1823. Besides Friedrich, Dahl became the second major figure in, and an important stimulus to, Romantic landscape painting in Dresden.

In this nocturnal vista of the well-known panorama of buildings along the Elbe River, Dahl so memorably reproduced the unique atmosphere of Dresden, a major artistic center and home to the Electors of Saxony, that this large painting pays homage to the genius loci of the artist's chosen home. Silvery moonlight transforms the façades of the splendid baroque buildings on the banks of the Altstadt, the glittering festiveness enveloped by a poetic atmosphere, which ultimately becomes a fascination with the location in itself. The subject may recall pictures by Friedrich, yet Dahl was less concerned with the symbolic than a true-to-life description of the remarkable cityscape. He captured this scene from almost the same viewpoint as Bernardo Bellotto's well-known *View of Dresden from the Right Bank of the Elbe with the Augustus Bridge* (1748, Dresden, Gemäldegalerie Alte Meister) almost a century earlier. Above the broad arch of the bridge, teeming with people, we can make out the buildings on the Brühl Terrace. At the left is the former Brühl painting gallery where the Dresden Art Academy held its annual exhibition, and where, beginning in 1819, Dahl exhibited his paintings with great success. Further to the left is the former Brühl library, occupied from 1791 by the Königlich Sächsische Kunstakademie, of which Dahl became a member in 1820 and a associate professor in 1824. Behind this structure rises the powerful and elegant dome of the Frauenkirche, the jewel of Dresden's skyline. Destroyed in 1945, it was only recently (thanks in part to the donations from many international benefactors) rebuilt in splendor, a symbol of the city's newly revived civic spirit. To the right, beside the more distant church tower of the Kreuzkirche am Altmarkt, is the Katholische Hofkirche, and behind its nave the Hausmannsturm of the Royal Palace soars into the night sky. The outlines of these buildings are reflected in the quietly moving surface of the water, the glow of warm light from the windows of buildings along the river enhancing the charm of the scene. The figures on the near shore, going about their everyday activities, harmonize with the mood of the ebbing day. The last work of the day nears completion; the evening fires are already lit. A horse and rider seek refreshment in the cool flow of the river, and from this vantage point the hustle and bustle on the bridge withdraws into the far background.

Dahl repeatedly portrayed the town's idyllic silhouette by moonlight in works commissioned by, among others, the Austrian and French envoys to Dresden. Of the three well-known versions of this subject, this work is by far the largest. Over the years the painting has become one of the most famous and best-loved works in the Romantic painting collection of the Galerie Neue Meister.

GERD SPITZER

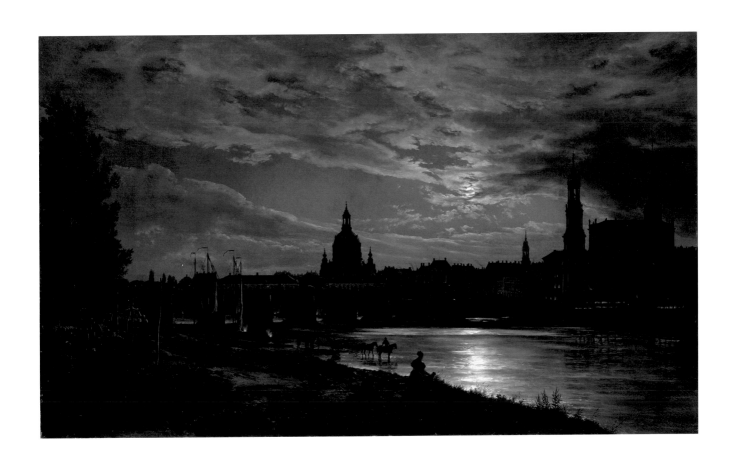

Ludwig Richter

1803 Friedrichstadt near Dresden – 1884 Dresden

Bohemian Pastoral Landscape (Landscape with Rainbow) 1841

Böhmische Hirtenlandschaft (Landschaft mit Regenbogen)
Signed lower left: L. Richter / 1841. On the pitcher: 1841 R
Oil on canvas, 71 × 106 cm
Acquired in 1908 as a bequest of Countess Ernestine von Holtzendorff, Niederlössnitz, near Dresden
Galerie Neue Meister, Staatliche Kunstsammlungen Dresden (Gal. Nr. 2229 A)
Lit.: Friedrich: Catalogue Raisonné no. 65

The son of an engraver and professor at the Dresden Art Academy, Ludwig Richter is probably even today the most popular German artist of the 19th century. His immense fame, which came during his lifetime, however, owed less to his paintings than his activities as a graphic artist and book illustrator, and above all to his plentiful woodcuts. After a stay in Rome from 1823 to 1826, Richter initially painted Italian landscapes almost exclusively, but around 1835 he turned decisively to his native land for subject matter. In contrast to his numerous landscape drawings, Richter never intended his finished paintings to be exact reproductions of views seen in nature. They were instead idealized compositions that gave human beings, through the figures in his pictures, their own realms of action and experience. The artist initially titled the painting *Landscape with Rainbow*; its present, more specific title only came later. This work surely does not represent a specific topography at a precise moment, but the carefully composed landscape creates an evocative frame for the figures, whose presence and actions articulate the work's meaning. A group of people, representing a wide range of ages, is about to cross a ford in order to take their herd to the pasture in the middleground. The strong diagonal movement of the train of figures, however, makes the promising rainbow in the amorphous blue distance appear to be the goal of their journey. Richter projected larger ideas into his landscape compositions, and one of his central themes was humankind's path through life towards the "eternal homeland." Purposeful wandering; homesickness as a persuasive feeling of longing for the fatherland; mankind's pilgrimage through earthly life: all of these allegorical images are found repeatedly in Richter's notes. Thus as early as 1828 the artist noted in his diary, "Observation of nature [...] always shows us, that like the holy patriarchs, we are strangers and pilgrims here, journeying towards a better homeland." At that time Richter was particularly impelled by the "Effort to bring art or rather landscape painting into harmony with my inner life, with Christianity." In 1845, in a letter to his son Heinrich, he wrote, "And homesickness itself is also only a shadowy image of our homesickness for a heavenly homeland, which we all—as we faithfully believe—should reach. Here we are everywhere 'strangers and pilgrims of god,' who have their right to be citizens in the hereafter."

GERD SPITZER

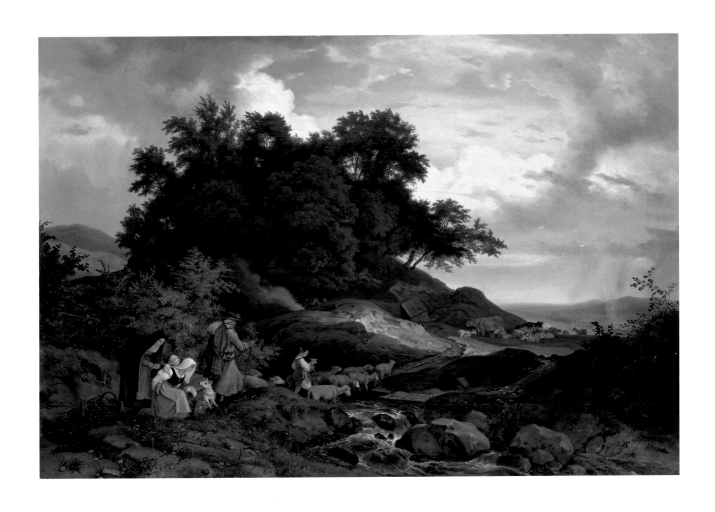

Wilhelm Leibl

1844 Cologne – 1900 Würzburg

Portrait of Baron Wilhelm Schenk von Stauffenberg 1877

Bildnis Wilhelm Schenk Freiherr von Stauffenberg
Oil on canvas, 117 × 88 cm
Acquired in 1917 from an art dealer in Berlin
Galerie Neue Meister, Staatliche Kunstsammlungen Dresden (Gal. Nr. 2407 A)
Lit.: Waldmann: Catalogue Raisonné no. 149

Leibl is one of Germany's most important portrait painters of the 19th century. From 1871 to 1873 he was the artistic and intellectual center of a small group of young painters in Munich, the so-called "Leibl-Circle." Turning away from established salon painting, they sought new artistic forms and subjects in the rural areas beyond the city. Their declared goal was to depict people and nature unflatteringly and realistically. They received important inspiration for their work from contemporary French painting, especially from Gustave Courbet's realism, and from 17th-century Dutch painting, particularly Frans Hals. The main subjects of Leibl's art were multi-figure and portrait paintings, including this commissioned portrait of the officer Wilhelm Theobald Schenk, Baron of Stauffenberg (1837–1879). Although Leibl does not clearly depict Stauffenberg's rank on his Flugel Adjutant's uniform. He was probably a Lieutenant Colonel. The dynamic and self-confident 40-year old proudly presents six medals and badges of honor, among them the Knight's Cross 2nd class and the Prussian Iron Cross 2nd class.

In the course of his successful military career Schenk was appointed in 1866 to the position of Flugel Adjutant to the King, and three years later to Royal Chamberlain. In 1868 he married the Countess Irene Waldkirch, although the two only enjoyed a few years together, for the Baron died at the age of 42 without leaving any children.

This portrait was thus created only two years before his death. Leibl portrayed Schenk in three-quarter profile and almost life-size against a large black-brown field of color. Leibl concentrated completely on the figure of the officer and left out genre-like narrative details, creating a classically austere composition, and forming the sitter's monumentality with the solid outline of the black coat against the dark background. Only the bright flesh tones of face and hands, the uniform's colored trim, and the glitter of the medals create radiant points of contrast. The paint is evenly applied *alla prima* (wet-in-wet) without underpainting, and Leibl reproduces the material structures of the skin, hair and uniform with masterful technical perfection. The quest for a "consummate" style of painting, which he believed could portray the model truthfully and appropriately solely through its immediacy, substance, and artistic form, was for Leibl a lifelong struggle with the highest aesthetic goal being the achievement of a technically perfect method of painting.

HEIKE BIEDERMANN

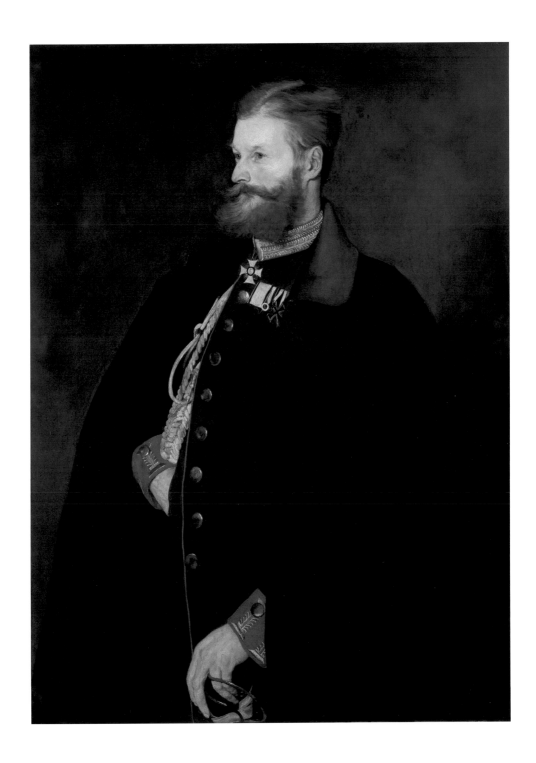

Arnold Böcklin

1827 Basel – 1901 San Domenica/Fiesole

Summer Day 1881

Der Sommertag
Initials at lower left: A. B.
Oil on panel, 61 × 50 cm
Donated in 1902 by Karl August Lingner, Dresden
Galerie Neue Meister, Staatliche Kunstsammlungen Dresden (Gal. Nr. 2534)
Lit.: Andree: Catalogue Raisonné no. 359

The Swiss painter Böcklin spent many years of his life in Italy. He found numerous sources of inspiration for his work in that country's rich artistic culture as well as in its southern Mediterranean landscape. He lived in Florence from 1874 until 1885, and it was there in 1881—one year after his famous painting *Isle of the Dead* (first version)—that he created *Summer Day*, its cheerful summery landscape a counterpoint to the earlier dark, melancholic work. The deep perspective and unreal, glowing colors appear like a dream vision from bygone happy days of childhood; a time full of serenity, harmony, vigorous hope, and poetic idyll. The bright, soft bodies of the bathing youths frolicking on the riverbank are only sketchily rendered, without elaboration of their anatomy or facial features. A deep blue shimmering river winds through luscious green meadows, leading the viewer's gaze beyond the towering poplars to a city in the distance. The silhouettes of the naked bodies and the slender tree-trunks reflect brightly in the water, and the low horizon line concentrates the action in the foreground as if on a stage. An intense contrast between lush green and blue tones, juxtaposed in broad planes, dominates the work. Woven into an austere, almost ornamental form and flatly painted in places, the composition is reminiscent of works of the early Italian Renaissance. In fact, Böcklin studied the painting of that period intensely. Together with the painters Anselm Feuerbach and Hans von Marées, he was among the German artists active in Rome, also known as "Deutsch-Römer," who sought their roots in the art of the Italian Renaissance in their efforts to bring about an intellectual revival in painting.

In a unique way Böcklin also transmitted his own moods and feelings into the landscape. *Summer Day* delineates a vision of earthly paradise: The children, completely integrated into their surroundings, reveal his desire for the unification of humanity with nature, while their carefree, cheerful game illustrates the longing for a "natural" Arcadian life. At the same time, the flow of the water and the distant city refer to the unstoppable passage of time. In many of his works Böcklin contrasted the rapid changes in society brought on by industrialization at the end of the 19th century with his own visual imagery, in which he expressed his dreams and religious ideas.

He laid particular emphasis on symbolic content in his later work. In addition to paradisiacal fantasies, he also expressed, as in the various versions of *Isle of the Dead*, the "other side": the gloomy and tragic aspects of existence. While the contemporary Impressionists strove to dissolve form in light and color, Böcklin's idyllic landscapes, with their austere, lucid compositions and meaningful content, seem instead to mediate between late Romanticism and Symbolism.

HEIKE BIEDERMANN

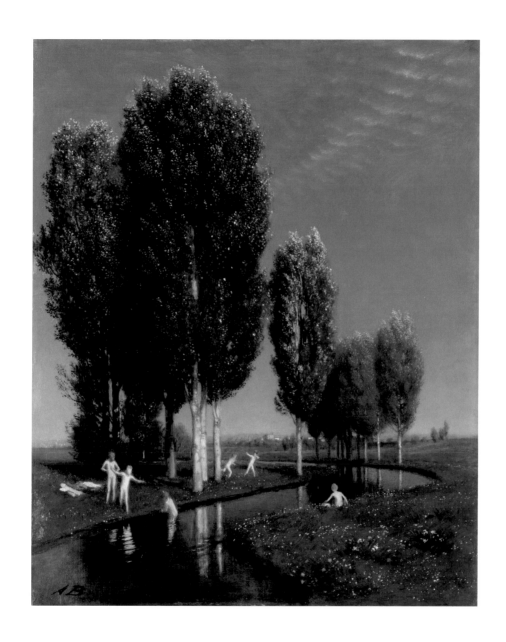

Lovis Corinth

1858 Tapiau (East Prussia) – 1925 Zandvoort (Netherlands)

Group of Women / Friends (Large Version) 1904

Frauengruppe / Freundinnen (Große Fassung)
Signed top center: Lovis Corinth 1904
Oil on canvas, 98 × 119 cm
Acquired in 1923 from the art dealer C. Nicolai, Berlin
Galerie Neue Meister, Staatliche Kunstsammlungen Dresden (Gal. Nr. 2580 C)
Lit.: Berend-Corinth: Catalogue Raisonné no. 298

The bodies and limbs of four nude models intertwine within a whirlpool created by a fast, generous flow of brushstrokes, their skintones in tune with the overall refined, light gray-brown palette. Only the painting's central axis is cautiously accentuated with color, with the blue-green cloth answering the red tones in the soles of the feet. The model on the left leans back against the chaise longue, absentmindedly letting her arms hang down. Satiated and self-absorbed, the woman sitting between her legs stretches out her arms. The figure sitting upright and forming the group's center is possibly the artist's wife. She turns her face towards a woman nestled against her, whose bent legs, extending downward, terminate the composition.

Titles such as *Harem* and *Odalisques*, under which the painting was exhibited during the artist's lifetime, distinguish this work from the academic, anonymous, and alienating manner of using nude models purely as a formal exercise. The title *Friends*, which first appears in the catalogue raisonné compiled by Corinth's wife, connects this work to a small version of the painting with the same title, and refers to its homoerotic content.

The artist captured landscapes, flowers, and even the human body as elements of nature, with immediacy and brio, and translates those qualities into painting. These qualities are likewise reflected into the way that the artist presents himself in his work; he sees himself as a confessor of his vitality and desire-driven nature, in a Nietzschian spirit. Scholars have repeatedly claimed that Corinth's art, especially given his increasing approach towards the abstract in his later work, not only has roots in the middle-class artistic and salon traditions of the 19th century, but also forged a link with the modernity of Expressionism.

Corinth's group portraits and portraits of women, however, should not be appraised solely in terms of a refined, early 20th-century painting culture, or as *l'art pour l'art*. Corinth's modernist way of painting goes beyond salon art, and his search for self-expression and sensuality also belongs to a restrictive period in which one normally never even saw a lady's ankle. At the same time, a younger generation of painters, those of *Die Brücke* (1905–13), in their quickly drawn nudes and their way of living and working together with their models, lent credibility to a new, utopian lifestyle. Corinth's contemporaneous search for a closeness of life and art belongs in this context, even though he moved in more elevated social circles with stricter moral values and did not seek new paths by radically breaking with the tradition of painting. Yet it would be an oversimplification to view the younger generation as avant-garde and in discord with society, and the older generation as conforming hedonists legitimized by academic tradition. As *Friends* demonstrates, Eros and sensuality were central to Corinth's work even before his stroke in 1911, which dramatically loosened his painting style.

<div align="right">BIRGIT DALBAJEWA</div>

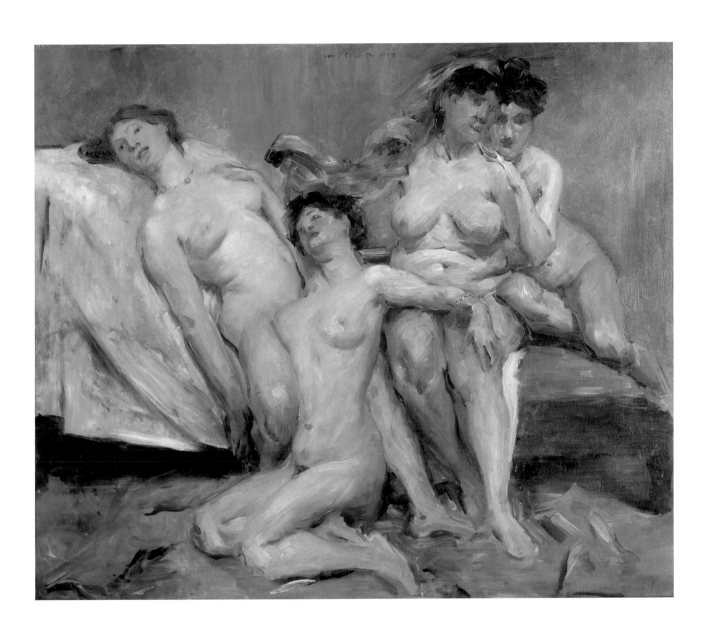

Max Liebermann

1847 Berlin – 1935 Berlin

Portrait of Alfred von Berger 1905

Bildnis Alfred von Berger
Signed upper right: M. Liebermann
Oil on canvas, 111 × 92 cm
Acquired in 1914 from the artist with funds from the Pröll-Heuer endowment
Galerie Neue Meister, Staatliche Kunstsammlungen Dresden (Gal. Nr. 2457 B)
Lit.: Eberle: Catalogue Raisonné no. 1905/1

This portrait of the Director of the Deutsches Schauspielhaus in Hamburg, Alfred von Berger (1853–1912), is one of Liebermann's major works and an outstanding example of Impressionist portraiture. Liebermann turned to portraiture relatively late in his career, with the 1891 *Portrait of Mayor Petersen*, commissioned by the Director of the Hamburger Kunsthalle. This work initially received little recognition, but after Liebermann had established himself with various other portraits in 1903/04, a further portrait was commissioned for the Kunsthalle in Hamburg, that of Alfred von Berger. A second version of this painting still exists in Hamburg, while the first version, painted from life and more energetically executed, initially remained in the artist's possession and was purchased for the Dresden Gemäldegalerie in 1914.

Berger, born in Vienna and appointed in 1900 to the newly founded theater in Hamburg, was highly educated and multitalented. After studying law, he completed a PhD in 1876, and qualified as a lecturer in aesthetics at the University of Vienna in 1886. A short time later, he became Artistic Secretary of the Burgtheater in Vienna and was universally recognized for his work. Even today he is considered one of the most capable people working in German theater in this era.

The massive physique of this sensitive, intellectually active man seemed at odds with his character. Alfred Lichtwark pointed out this contradiction to Max Liebermann in his letter of January 7, 1905: "A wonderful head, ugly, almost grotesque, but the face is like a mask behind which one senses great beauty. It flashes through all over."

In his painting, Liebermann successfully captured an amazingly vivid image of Berger's brilliant nature and pleasure-loving vitality. Like the 17th-century Dutch portrait painter Frans Hals, whose works influenced Liebermann throughout his career, he represented his model's movement and expression at a specific instant. Berger, caught in conversation, is parting his lips to speak while casually leaning on his thigh, on the verge of taking a puff on his cigar. The use of impasto, the fast *alla prima* (wet-in-wet) brushstrokes, and the paint applied thinly enough to allow the ground to show through, all testify to the painter's confident ability and masterful aplomb in portraying figures and materials.

HEIKE BIEDERMANN

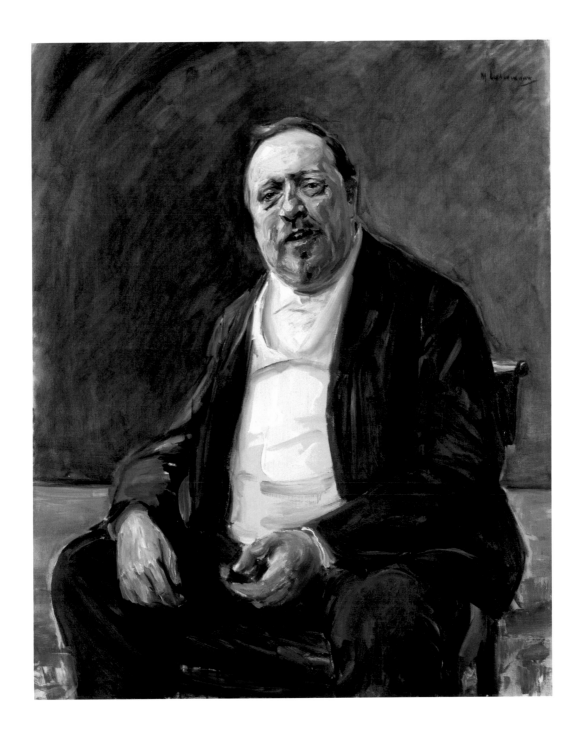

Otto Dix

1891 Untermhaus near Gera – 1969 Hemmenhofen

Yearning, Self-Portrait 1918/19

Sehnsucht, Selbstbildnis
Signed upper right in the rose: Dix
Oil on canvas, 53.5 × 52 cm
Gift of Marianne Britze in 1970, Bautzen
Galerie Neue Meister, Staatliche Kunstsammlungen Dresden (Gal. Nr. 3781)
Lit.: Löffler: Catalogue Raisonné 1918/1

Dismissed from military service in December 1918, Dix was one of the few artists who survived World War I in the trenches of the Eastern Front, rather than on the periphery of the conflict. Whether Dix actually brought the self-portrait *Yearning* from his hometown Gera (Thuringia) under his arm on the running board of an overcrowded railway car, or completed it after his arrival in Dresden, is something his biographers could not fully ascertain during the artist's lifetime.

After a four-year interruption of his art studies during the war, Dix returned to the Art Academy in Dresden. In the revolutionary year 1919, this "city of art" was completely in the grip of sociopolitical and cultural reforms. Dix later reported, "1919 back in Dresden, where painting continues with dry hemp, sugar and water. Art Academy in Dresden under Feldbauer, where I provoked a Cubist epidemic in painting class." He painted *Yearning* at the end of a phase of searching, positioning himself in relation to the realism of the Old Masters, Expressionist experimentation with color, and an intensive exploration of Cubism, Futurism and Orphism. *Yearning* is the first of the 1919 series of so-called cosmic pictures [*kosmischen Bilder*], in which the artist dealt with the great themes of mankind, Eros and death, by freely reinterpreting symbols and pictorial schemes from Christian and ancient art.

In diametrically arranged pairs, the bull and the rose appear as earthly symbols, and the moon and sun as cosmic ones. Man, the artist, appears godlike in the cycles of day and night, and of flora and fauna. Other works by Dix—for example, a 1919 woodcut in which he depicted his girlfriend as the sun and himself as the moon—indicate that the sun and moon stand for female and male principles. This personification of the symbols also appears in *Yearning,* and recalls other anthropomorphic Christian symbols. Dix drew on Ottonian symbolism, in which the whole universe participates in Christ's death, and personifications of the sun, moon, earth, and ocean attend the Crucifixion.

Forming a nimbus or a crown of thorns, the four symbols (or faces) revolve around the head of the artist, just returned from the insanity of war, like moons around a central sun. Painted cool blue, the face is detached, an imprint on a veil against a dark background. Only the provocative red of the forlornly open lips breaks up the blue face, and the four symbols appear in the contrasting colors of red, yellow, and green. Color gradients flowing into white or yellow delineate prismatic breaks, shadow and axis lines, giving rise to a cross behind the head. Like the blades of a windmill, the diagonals create a circular motion of the symbols of universe and nature, pivoting around a point between the eyes. Other Dix self-portraits of 1919—*I Dix am the A and O* and *Prometheus – Boundary of Humanity*—take on similar themes, before the artist left Expressionism for Dada, biting satire, social criticism, and later for New Objectivity.

The painter Marianne Britze (1883–1980) donated this work to the Gemäldegalerie Neue Meister in 1970. As a well-to-do student at the Dresden Art Academy, she had helped Dix in 1919 as he was just returning from the war by giving him "a couple of hundred marks" (Joachim Uhlitzsch), and received the painting in gratitude as a gift.

BIRGIT DALBAJEWA

Karl Schmidt-Rottluff

1884 Rottluff near Chemnitz – 1976 West Berlin

Landscape in Rottluff 1921

Landschaft in Rottluff
Signed lower right: S. Rottluff
Oil on canvas, 87.5 × 101 cm
Acquired in 1972 from a private collection in Karl-Marx-Stadt (Chemnitz)
Galerie Neue Meister, Staatliche Kunstsammlungen Dresden (Gal. Nr. 3824)
Lit.: Grohmann: Catalogue Raisonné p. 293

In 1905 four young architecture students in Dresden, including Karl Schmidt-Rottluff and Ernst Ludwig Kirchner, founded the artist group *Die Brücke*. A few years later, the members of this group developed a collective style, using unconventional concepts of color and form. Dresden had thus become the birthplace of Expressionism in Germany. The artists moved to Berlin in 1911, and the group broke apart in 1913 when the members each went their separate ways. Schmidt-Rottluff and the painters of *Die Brücke* differ from other avant-garde artists attracted to compositional experimentation at the beginning of the 20th century in their particular affinity for direct experience. Their paintings are always distinguished by the inclusion of a slice of everyday life, a concrete observation, or a notation of something just seen. Formally, however, Schmidt-Rottluff pursued the abstract idea of the independent vitality of color and form. The elements of his landscape are simple and commonplace, and its coloration is unrestrained and quite distinct from that of a study taken directly from nature.

The roof ridge of the narrow, white mountain cottage in the foreground, typical of the Erzgebirge, the mountain range south of Chemnitz, draws the gaze irresistibly into the painting's depths. Also leading to this vanishing point is the curving blue roadway, which Schmidt-Rottluff sets as the painting's main focus. The buildings, so freely drawn by this architecturally-trained painter, appear askew, because the vertical lines are not strictly parallel to one another. Schmidt-Rottluff paints with liveliness and turbulence, even rapidity, departing from versimilitude in the rhythms of the figures, buildings, and windows; in the volatility with which they are dashed off; in the cadence of the slightly skewed telephone poles and trees; and especially in the arrangement of color planes. The warm tones of the background offset the composition's illusion of depth. The yellowish-green color scattered like a mosaic throughout the entire picture, maximizes the luminosity of the reds and particularly the radiant blues. The focal point of the narrative of villagers peacefully strolling the streets of Rottluff is the radiant orange of the shock of hair shining in sharp contrast to the blue street. Schmidt-Rottluff discovered this color combination during a winter stay in 1921 in his home town Rottluff nearby Chemnitz, where he recorded it on a postcard that he sent to Lyonel Feininger's wife Julie.

Around the beginning of World War I Schmidt-Rottluff's palette changed as he turned away from the pathos of pure colors in favor of much more subdued coloration, derived from mixed tones. He no longer defined the form of objects with color itself, but rather with contours and modulated colors. In this 1921 village scene, his figures no longer, as previously, fill the picture plane nor are they monumental, but they are far more closely associated with the landscape, expressing a fundamental change in the relationship between the painter and the world around him.

BIRGIT DALBAJEWA

Werner Tübke

1929 Schönebeck/Elbe – 2004 Leipzig

Requiem 1965

Requiem
Signed lower center: Tübke 65
Mixed technique on wood, 28 × 44 cm
Donated in 1966 by the Council of the City of Leipzig
Galerie Neue Meister, Staatliche Kunstsammlungen Dresden (Gal. Nr. 3636)

The victims of an execution are laid out in a semicircle in front of a crouching mourner, above whom a symbolic white dove appears. Hanging on the prison wall that closes off the stage-like pictorial space is an evergreen wreath of honor in memory of the victims. Thus, the moment after the execution and the later, reverent commemoration are condensed into a simultaneous event. The indifferent brightness of the gravel on the courtyard shifts the scene into a state of timeless, abysmal stasis. Likewise, the wall with window openings remains faceless and mute, with no indications that could betray the place and time of the event. Like discarded marionettes in a play or itinerants in the unregulated territory of facelessness and lawlessness, the victims are shown dressed in historical robes and fabrics. They do not appear cadaverous but rather elevated into a state beyond contemporary occurrences and beyond the comprehensible. Their luxurious, complex garments, painted in fine, transparent layers and precious hues, assume inscrutable forms. The twisted dead in *Requiem*, unlike in later paintings by Tübke, do not solely derive from motifs borrowed from Old Master paintings. Despite all mannered poses and drapery, the figures, like concrete portraits, have veristic and moving passages, such as the pale neck of the redheaded figure at the front left.

In the Federal Republic of Germany (FRG) around 1964, discussions raged about the statute of limitations for Nazi crimes and the continued employment of former Nazi judges. Tübke, an East German painter working in Leipzig, reacted to this with a dramatic painting cycle, begun with the small, mixed technique *Requiem*. To proceed from an illustration of current affairs to a universal statement was the self-declared goal of the artist who, schooled in the German Democratic Republic (GDR) in the spirit of Socialist Realism, primarily worked on monumental and mural commissions. This escalation into the universally symbolic and mysteriously bizarre is typical of Tübke's entire œuvre. Just as his portraits of the fictitious Nazi judge Dr. Schulze, which immediately followed the aforementioned painting cycle, could be read in part as allegories of contemporary GDR power structures, *Requiem* conveys, among other things, the personal tragedy of internment in a camp or prison. As yet no biographical connection has been made with the unjustified imprisonment of the young Tübke in a Soviet prison camp in 1945/46. These prison camps, set up after the war's end in the Soviet occupation zone, were considered a taboo subject until end of the GDR.

After 1949, in the early years of the GDR, Bertolt Brecht set his theatre pieces in the past or in distant regions in order to address contemporary topics. The painter Tübke intensified this approach with extremely close references, which he used right from the beginning of his career, to the art of the 16th through 18th centuries. Tübke's retrogressive tendencies, his mannerism, and his closeness to the GDR state government have repeatedly been questioned. Some scholars stated that the painter, in a mixture of styles that overcame a narrowly conceived concept of realism, an independent path. His paintings by no means were to end in withdrawn flight from the world, but were rather able to undermine existing ideologies and suspend them (Eduard Beaucamp, Gerd Lindner).

BIRGIT DALBAJEWA

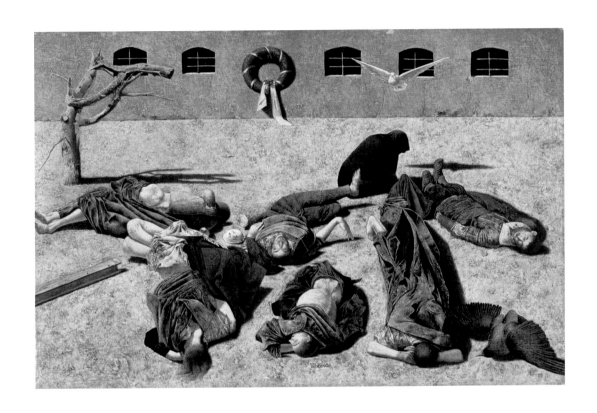

Gerhard Richter

b. 1932 in Dresden

Cloud Study (Contre-jour) 1970

Wolkenstudie (Gegenlicht)
Oil on canvas, 80 × 100 cm
On long-term loan from a private collection to the
Galerie Neue Meister, Staatliche Kunstsammlungen Dresden

Between 1969 and 1971, alongside his landscapes and abstract paintings, Richter painted a small group of 18 romanticized cloud paintings. Half a decade later he took up this subject once again in 6 large-format paintings. *Cloud Study* from 1970, at 80 × 100 cm, is among his smallest but most concentrated and vigorous compositions on this subject. Richter created all of the works from photographs that he took himself. In his so-called *Atlas*, the collection of photographs he used as models, there are dozens of variations of such cloud photographs as well as the specific image he used for *Cloud Study*.

In 1970, the same year in which he produced *Cloud Study*, in response to the question of his motivation behind the landscapes, seascapes, and cloud pieces he was currently producing, Gerhard Richter replied that he had wanted to paint something beautiful. This confession conceals a touch of irony and subversion. Within an artistic environment propagating the overthrow of all traditions and an "abandonment of the image," Richter's conventional panel paintings and classical themes were a provocation.

Richter's small series represents a broad spectrum of possible cloud formations, ranging from almost solid, nuanced gray blankets of clouds to the rich contrasts of this work. Compact mountains of clouds tower up dramatically here against the blue sky. Dark, shadowy sections, through which the bright sunlight breaks, are strongly illusionistic and intensely captivating. In *Atlas*, Richter experimented further with this effect. Using a supplementary pencil drawing, he placed the photograph within an illusionistic space, where it occupies an entire wall and thus appears to have attained gigantic proportions. With utopian plans such as these, Richter links his work to romantic pictorial concepts of the contemplative and the sublime. There, portrayals of the sky were metaphors of the cosmic and the presence of God. Pictures and drawings of cloud formations also had secular functions. With no concrete form or fixed contours, they allow extensive painterly freedom that extends to the borders of abstraction, and their subtle coloring and soft color transitions characterize the entire pictorial surface.

In his cloud paintings, Richter has most notably found an affinity with his own gray photographic images. Although their painterly blurring has repeatedly been compared with the blurring of unsteady amateur photographs, for Richter an epistemological experience becomes apparent in the motifs' inaccuracy in comparison with their pictorial models. In an interview in 1972, he expressed himself accordingly: "I can say nothing more clearly about reality than to express my relationship to reality, and that has something to do with blurring, uncertainty, fleetingness, partialness, or whatever." To Romantic artists, depictions of cloud formations symbolized the transience and changeability of nature, at whose mercy humankind is destined to be. In contrast, in the obscuring of his imagery, as in the softly painted *Cloud Study*, Gerhard Richter perceived the formulation of an individual cognitive ability. More subtly than in the blurred photographs, *Cloud Study* of 1970 thus shows the discrepancy between the painted presence of reality and the limits to its cognitive perception.

<div align="right">DIETMAR ELGER</div>

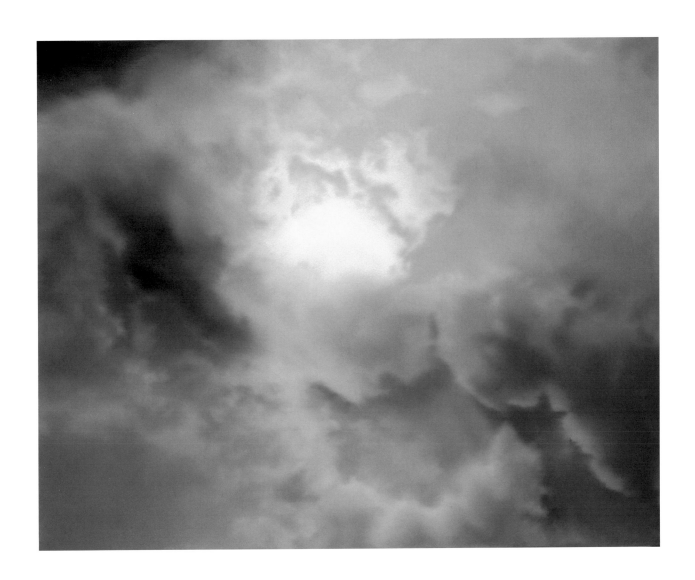

JEANNE ANNE NUGENT

Overcoming Ideology:
Gerhard Richter in Dresden, the Early Years

Constructing a chronology from Caspar David Friedrich's landscapes to Gerhard Richter's most recent abstract paintings presented in *From Caspar David Friedrich to Gerhard Richter: German Paintings from Dresden* invites the question of just what has happened to the "German tradition of painting" in the years that separate the two artists' careers. Richter, as the master and confounder of a number of historical genres and styles, provides a fitting protagonist in the story, for he seems to deconstruct history even as he reconstructs it. In discussing Richter's landscapes for an exhibition of German painting from 1790 to 1990, the German art historian Hubertus Butin once described Richter's oft-cited allusions to Friedrich's work as a form of "un-romantic Romanticism."[1] Butin emphasized how Richter's use of the camera in locating landscape motifs for his paintings challenged the Romantic conception of nature as an "extracurricular topos," or a place outside everyday experience, where the artist and the viewer "devoutly immerse themselves in a sublime natural spectacle."[2] Pointing away from nature to the chemical and physical processes of photography that Richter's photo-paintings seem to replicate—through effects like cropping and the blur, as well as details such as the traffic signs, paved roads, and modern houses that appear in his landscapes—Butin rightly noted the tension between the un-romantic effects of the contemporary artist's approach and its deliberate historicism.

The present exhibition similarly begins with Romanticism, but ends instead with Richter's latest series of abstract paintings—a juxtaposition that complicates the easier comparison of Friedrich's landscapes with Richter's earlier photo-paintings. With a series title of *Wald*, the new work approaches the setting of many Friedrich's paintings, though without the older master's naturalism.[3] Although the new series—apart from its title—lacks the photo-paintings' obvious grounding in the earlier landscape tradition, Richter's use of color, light, and atmosphere transposes the expressivity of Friedrich's example into a new register. In doing so, he reflects upon painting's past in a way that nevertheless inhabits another topos: abstract painting viewed as a postwar genre in decline. The coolness of Richter's series echoes Friedrich's frozen terrain, where a sunrise or an isolated figure ever so slightly warms the land. The *Wald* cycle, as I discuss in greater detail in a separate catalogue entry, consists of twelve abstract works that are uniform in size and manner of execution.[4] The repetition of vertical and horizontal strokes from a large squeegee loaded with paint creates fields of dense color decidedly cool in their formulaic construction. Yet an occasional scrape of the surface wanders diagonally across the grid-like structure to invoke a diminished human presence analogous to the lone figures found in Friedrich's works.

Richter's entire enterprise—not restricted to his interest in Romanticism—engages art historical paradigms in a self-referential scheme in which photography

plays a salient role. Richter not only alludes to a range of past genres and styles—from Romantic landscape painting and Dutch still life to gestural abstraction, monochrome painting and installation art—but he also makes the structure of photographic reproduction the single consistent organizing principle in his work. Photographs not only provide the obvious basis for Richter's several series of photopaintings, but also for many of his earlier abstract paintings. Richter recently affirmed the close relationship that photography and abstract painting continue to hold for him, stating, "any abstract daubings can be easily reconciled with a realistic photograph. These are two illusionistic modes of creating images that are brought together there."[5] He clarified those two modes as "the photographed reality and the real color traces."[6] Thus the chemical and physical processes of photography discussed by Butin easily find an equivalent in painterly marks, regardless of whether they operate in the service of figuration or abstraction. Richter further complicates the painting/photography relationship by photographing the finished photo-paintings and issuing certain well-known works such as *Uncle Rudi* and *Betty* in photographic editions; or, alternatively, by photographing his own abstract paintings as the subject of independent photographic series. This self-reflexive dimension of Richter's œuvre may not be readily apparent in his works in this exhibition. Yet when one considers Richter's entire body of work, it is precisely the self-conscious pairing of photography with painterly illusionism that structures the artist's relationship to historical predecessors.

The role of mediation in Richter's work is complex and has been studied extensively. However, one important aspect of Richter's photographic practice has been overlooked: an understanding of the artist's use of the camera in Dresden during a period when "mediation" existed as a nefarious fact of life in the GDR.[7] The photopaintings that Richter produced in the 1960s after relocating to the West may have reinscribed photography into the ontological and epistemological registers of painting's history, as Benjamin Buchloh established in 1977 when he placed Richter's work in discourse with Marcel Duchamp's readymades.[8] However, Richter employed photography extensively well before his encounter with the neo-avant-garde in the West,[9] which did not start until 1961 in Dusseldorf: he learned to develop and print photographs in the 1940s, and he used them early on as an aid to painting, as a record of his own creative output, and as a way of circulating the works of forbidden modernists in the GDR. He frequently took pictures of art at exhibitions, including a few in the West, and photographed entire books with works by artists such as Pablo Picasso and Henry Moore that he circulated clandestinely among a trusted circle of friends.[10] Richter's early uses of photography in the GDR are completely in keeping with his later documentary projects that complement his œuvre, such as the *Atlas* and the various catalogues raisonnés that he himself has organized with the aid of assistants.

The fact that Richter's archival approach to studying and documenting art predated his arrival in the West shades the interpretation of his contribution to the "western" neo-avant-garde significantly. For one thing, it begins to account for his tendency to objectify abstraction both before and after he moved West. He began painting abstractly privately in the GDR and explored the European *informel* movement more thoroughly at the Dusseldorf Art Academy after resettlement. By then, abstract painting already had been mediated both by his own camera, which documented examples from books and exhibitions, and by the ideological claims made about it on both sides

of what Andreas Huyssen has termed "the great divide."[11] In the West, abstraction was promoted positively as an "international language" capable of rendering subjective experience transparent through the artist's individual handwriting.[12] In the East, abstraction was viewed negatively as "formalist" for its distortion or elimination of the human form, which seemed to dehumanize the subject. For Richter, neither position satisfied his expectation for painting to transcend ideology. Moreover, the mediating device of the camera shifted the presentation of human subjectivity away from the trace of the hand to its mechanical reproduction.

In an exhibition that begins with Friedrich, the Romantic, and ends with Richter, it is tempting to reformulate Robert Rosenblum's familiar history of a Northern Romantic tradition, which he traces from Friedrich to Mark Rothko, with Richter in mind.[13] Alternatively, because of the dominance of Richter's abstract paintings here, one might look to the example of Werner Haftmann's developmental narrative of pre-war and postwar abstraction, which he presented in the first two *documenta* exhibitions at Kassel. Yet neither of these theories accounts adequately for Richter's decade-long engagement with modernist forbearers while still in the GDR, because both are concerned with a western teleology that ends in postwar abstraction. Nor does either model fully anticipate the interest in mass-mediated images and processes that would dominate the neo-Dada, Pop, and *Nouveau Réaliste* experiments of the generation after Abstract Expressionism to which Richter belonged.[14] Richter certainly would work through all of these "western" developments after his resettlement in the Federal Republic of Germany (FRG) in 1961; however, it was in the GDR that he acquired a fundamental knowledge of art history while studying painting under the dominance of Socialist Realism at the Dresden Art Academy (Hochschule für Bildende Künste Dresden since 1950). And although some interpreters argue that Richter's new abstract paintings can neither be historicized (as a genre) nor instrumentalized (in the service of ideology), the context of Richter's reception of art history in the GDR fundamentally determined just what counts for historicism and instrumentalism in the his work.[15]

This essay will not resolve the significant challenges that National Socialism and the Soviet dictatorship have posed for the historiography of German art since the re-unification of the two German states in 1990, though the project of bringing the utopian social and cultural projects of the eastern bloc countries closer to those of the West would expand our theorization of post-modernism significantly.[16] Nor will I attempt to reconcile Richter's œuvre with Romanticism definitively, tempting as that course might be.[17] Rather, I here provide a preliminary sketch of Richter's formative period in Dresden and hope to show how his early work instantiated the problem of received traditions almost from the outset of his training at the Dresden Art Academy. A significant aspect of the artist's process entailed an internalization of an art historical canon that developed in East Germany in opposition to the West and under highly problematic conditions. Unlike Rosenblum's story of the transplantation of a European tradition to American soil, or Haftmann's account of the reseeding of that tradition in Europe through *art informel,* Richter's "transplantation" from Dresden to Dusseldorf in 1961 defies such neat (and presumably organic) triumphalism. Yet his daily practice as an artist has affirmed painting as the artist's "highest form of hope," if conditionally and with noticeable ambivalence.[18] Following Butin's rhetorical posture of "un-romantic Romanticism," I propose "nontraditional traditionalism" as a

useful way to characterize Richter's approach to painting's history, conditioned by two dictatorships and the camera he often used to record it.

The Early Years

Details of Richter's life in Dresden have come to light slowly and incompletely. A private man who prefers the art itself to be the focus of critical attention, he has spoken little publicly about his personal life. Dietmar Elger's 2002 monograph gives the most complete summary of biographical information to date.[19] I will not attempt a full reconstruction of Richter's childhood and adolescence here. Instead, I bring to bear selected incidents from his life and work in Dresden insofar as they illuminate the problem of received artistic traditions in Germany, especially after Hitler's program of degenerate art exhibitions, the Holocaust, and the founding of the two Germanys in 1949. Richter's oft-stated opposition to leftist and rightist ideologies thus will be seen to originate in a pattern of resistance and accommodation that arose first within the GDR. Despite the unavoidable stamp of Socialist Realism on much of the young artist's efforts, stylistic experiment, avoidance of dogma, and an affirmation of humanistic values characterize his first decade of neglected work in the East.

Richter was born in Dresden in 1932, and he and his family moved away from the city on the Elbe in 1936 when his father, Horst Richter, found a teaching job in Reichenau (now Bogatyna, Poland) after an extended period of unemployment.[20]

Fig. 1 Gerhard Richter, *Landscape Study*, 1950
Oil on cardboard (dimensions and location unkown)

Horst Richter enlisted in the German Armed Forces [*Wehrmacht*] and was away from home throughout most of his son's adolescence. Because of the growing dangers of World War II, the family moved again to the more remote town of Waltersdorf in 1943. Waltersdorf is a small village located in the region of Oberlausitz, Germany, near today's eastern border with the Czech Republic and Poland. The area is known for hiking and skiing, as well as for the quaint timbered houses, which still dot the countryside. Richter's professional interest in art developed while living there. The surroundings inspired his childhood aspiration to become a forester, a professional interest that he abandoned because the labor was too demanding.[21] His early watercolors show his love of the landscape and convincingly portray the idyllic setting of houses set in the rolling hills (fig. 1).

The war interrupted Richter's early education and coincided with a series of art and non-art-related training that led eventually to his enrollment in the Dresden Art Academy. In 1945, his mother gave him his first camera for Christmas, and he soon learned to develop and print film from Werner Jungmichel, who owned a camera shop on the main street in Waltersdorf. After the war, Richter's father was prohibited from teaching because of his membership in the Nazi party. Richter was forced to leave the school because of the concomitant financial difficulties.[22] He then entered another high school under the charitable auspices of an organization known as the "People's Solidarity," which paid the tuition,[23] but according to Elger, he left that school after one year because of bad grades.[24] In 1946, he enrolled in a trade school in Zittau, where he learned stenography, typing, and bookkeeping and received his diploma in 1948.[25]

Richter also befriended a mural painter named Hans Lillig who was active in Waltersdorf and taught classes at the local high school in 1946.[26] Lillig's example contributed to Richter's later decision to specialize in mural painting at the Dresden Art Academy. Lillig completed a panoramic mural in a local high school in the late 1940s. It depicted a pastoral scene of field workers executed in a style similar to Paul Gauguin's works from Brittany and Vincent Van Gogh's paintings of farmers, though set in the hillsides near Waltersdorf.[27] Richter's schooling in Waltersdorf and Zittau coincided with the era of the Soviet occupation when the modernist art that was banned by the Nazis suddenly (and briefly) became available to the general public.[28] In a 2002 interview with his daughter Babette Richter, Gerhard Richter half-jokingly mentioned that he once wanted to be "as crazy as Van Gogh," indicating a romantic identification with the Dutch artist that might surprise those familiar with his mature professional demeanor.[29] In 1947, he also attended night school to study painting, although this experience is not mentioned in his subsequent application to the Dresden Art Academy.[30] His teacher may have been the mural painter Lillig.[31] In any case, Richter's adolescent work reflects a seriousness of purpose, competency of execution and, with approximately 200 examples found in Richter's private photographic portfolio of the period, a rather prolific output for such a young man.

Richter painted a watercolor entitled *Moonscape* in 1949 that typifies the experiments of his youth (fig. 2). The painting shows a striking command of watercolor, here manipulated freely into a moderately expressionistic composition. The moon dominates the page, dwarfing the twin rows of trees that lie below it as they recede diagonally and nearly meet at the center of the distant, low-lying horizon. The cross-like swaths of light behind the moon amplify its dominion by fixing the glowing orb to the page in a cosmic vision akin to Romantic landscape painting. Like the motifs of moons and crosses in works by Friedrich, such as *Two Men Contemplating the Moon* from the Dresden Gemäldegalerie (p. 45) or the *Cross at the Baltic Sea* from the Wallraf-Richartz Museum, Cologne (ca. 1808), Richter's young effort evokes a quasi-mystical meditation on nature that is neither encumbered by state-imposed standards of subject matter nor self-conscious in its relationship to Romanticism.

Fig. 2 Gerhard Richter, *Moonscape*, 1949 Watercolor (dimension and location unknown)

As a mature artist, Richter would engage with Friedrich, and the implicit Nazi co-optation of Romanticism through blood-and-soil ideology, more critically. Acknowledging that a "painting by Friedrich is not a thing of the past," he nevertheless asserted that art could transcend ideology and the burden of German tradition, if it were "good."[32] Initially the camera provided Richter a way in which to gain access to Romantic subjects in nature. The blurriness of the photo-paintings served as a metaphor for envisioning that tradition as something distant and already mediated. Yet it also enabled him to retain the painterly qualities of an artist like Turner—translated, ironically, through the restraint of Richter's mechanical brushwork (p. 77). However, that option would not arise, nor could it, until after he had absorbed fully the Stalinist refitting of the educational program at the Dresden Art Academy.

Sound Training at the Dresden Art Academy

In August 1950, Richter applied to the Dresden Art Academy but was rejected. By his own account, the "wild daubs" of his early watercolors distressed the admissions panel.[33] The committee recommended that he complete an apprenticeship at a "peoples-owned" factory and apply again. Heeding their advice, he took a job as a sign painter at DeWAG (Deutsche Werbe- und Anzeigen Gesellschaft) in Zittau and reapplied in May 1951.[34] Robert Storr has added that by painting images of Stalin and other approved subjects, Richter used the apprenticeship to gain entry into the system.[35] As part of his second, successful application, Richter submitted an essay entitled "Thoughts on the Situation of Art" in May 1951.[36] The essay fulfilled a requirement that all students write a "piece on a topical theme of general interest, which shows a connection to the student's future career."[37] Richter's essay opened with a dramatic summary of the contemporary problems facing artists after the war, written in colorful, youthful prose:

> If we want to provide a comprehensive picture of the art of today and the art of tomorrow, and in so doing link today's image of mankind with that of tomorrow, we should first consult the vividly illuminating book of history. I only need to turn back a few pages to reach the chapter on National Socialism, where we can see just what danced on the stage of fascism. Marionettes jumped to the droning rhythm of a music that had only one theme—war. And what hid behind the curtain was a cruel prison, in which all art languished.
>
> Yet suddenly all the shackles were broken and the day of the collapse of the thousand-year Reich came upon us like a powerful wind of freedom. It swept over the misery and the poverty, over the ever-mounting ruins and the defeated rulers lying about us.
>
> Out of the long years of slavery and disorder stormed a clever rider on horseback, conquering the hurdles of silence and relishing this sudden freedom with such a force that it inevitably led to error.[38]

The error led to "formalism," as Richter makes explicit over the next several pages. In the 1950s nearly all the modernist movements of the early 20th century, including Cubism, Expressionism, Surrealism, Dada, and Constructivism, were viewed with suspicion for not appealing to the general public through legible figurative presentations. Additionally, many Marxist critics viewed the distortions of the human form in the works by a number of artists such as Picasso and Salvador Dalí as a manifestation of the material destruction wrought by fascist imperialism through war and greed.[39]

Notably, however, Richter never used the term "Socialist Realism" in the essay, though he incorporated several key examples from the official literature supporting it into the subsequent narrative. In particular, he cited approvingly N. Orlow's 1951 *Wege und Irrwege der modernen Kunst* [The True and False Paths of Modern Art], a foundational document of Socialist Realism in Germany.[40] Orlow's article emphasized the correct path of realism over formalism and chided artists in the GDR who followed Picasso's misbegotten example, emerging as it did in a Parisian environment of bourgeois capitalism.[41] Richter also referred favorably to the East German author Stephan Hermlin's speech of 1951 before the Congress of Young Artists concerning the task of young artists to work collectively for a better future.[42] In echoing Hermlin's call,

Richter wrote: "Before us lies an enormous task, and we can and should confront it with optimism because we stand not alone. All that is great, noble, young, passionate, and enduring is on our side."[43] Most of Richter's work after his admission to the school that year demonstrated the optimism expressed in this essay. *Optimismus* emerged as a mode of Socialist Realism succeeding the decidedly pessimistic reflection of urban ruins evident in an array of German works in the immediate postwar period.[44]

It would be a mistake, however, to assume that Richter's attention to the state-set admission standards amounted to an acceptance of totalitarianism, Stalinism, or a monolithic Socialist Realism in 1951. Viewed broadly, the expectations of the art school for a socially involved candidate with a professed interest in the program-on-offer were standard fare in the application process. The political apparatus had only begun to install the Soviet model of Socialist Realism into the GDR's educational policy in 1951. The more generic call to figurative realism preceded it, and largely prevailed among the Dresden intelligentsia despite Moscow's best efforts to tie figuration to Soviet Socialist Realism. Richter's youthful enthusiasm and attention to the Socialist-Realist literature simply may indicate a seriousness of purpose directed at his goal of attending the prestigious Dresden Art Academy, despite passages that attain the pitch of a manifesto. The professed aspirations for painting and the potential to engage a long cultural tradition expressed throughout the essay are entirely consistent with his devotion to painting over the subsequent five decades of his career, even as doubts and reversals mark the stylistic shifts in his work. Socialist Realism remained a work-in-progress throughout the decades of its evolution and resulted in diverse and often contradictory expressions that continue to confound art historians who attempt to chart its course in the GDR. The most well-seasoned and politically motivated artists who returned to Dresden after the war, such as Otto Dix and Hans Grundig, also committed themselves to a realist style and an anti-fascist message in the late 1940s and 1950s. Not surprisingly, then, the ambitious 19-year-old from one of the easternmost provinces of Germany looked to the dominant paradigm of the era as he began to chart his professional career.

When Richter entered the Dresden Art Academy in September 1951 after a second successful application, the ghosts of a number of distinguished artists—from Friedrich and Gottfried Semper to Oskar Kokoschka, Vasily Kandinsky, and *Die Brücke* through Otto Dix and the *Neue Sachlichkeit* artists of the 1920s still permeated the halls. Hans Schulz, an art historian who taught at the Dresden Art Academy during Richter's tenure, cited this eminent history as an advertisement for the school's programs in the college catalogue.[45] The historical synopsis referred disparagingly to "the gradual turning away from a mastery of reality" after 1860, which led to a "formal aesthetic" with "negligible content."[46] Schulz briefly treated the intervention of National Socialism, primarily as a foil to celebrate the "most famous and progressive artist of the Academy," the realist Dix.[47] He made no mention of the persecution of other "formalist" artists in the 1930s, preferring to credit the "friendly assistance of the Soviet Union" for "reconciling the particular artistic traditions of Dresden" with "a progressive German art."[48]

In spite of the Nazi rupture of the Art Academy's artistic lineage, the traditional fine arts training long associated with it was restored rather quickly when the school reopened after the war.[49] Richter has praised the rigorous formal instruction he

received there, stating that the school provided a "very sound training" and "awakened [in him] a fundamental trust in art."[50] As the Academy's first postwar director, Grundig established majors in the three conventional disciplines of painting, sculpture, and printmaking and placed the study of the human figure at the cornerstone of the Academy's teaching philosophy.[51] His founding curriculum required beginning students to spend fifteen hours per week working from nude models and another fifteen hours working from nature through direct observation.[52] This included studies of animals, landscape, anatomy, and drapery as well as drawing from memory.[53]

Fig. 3 Gerhard Richter, *Nude Studies*, 1954 Drawing (dimension and location unknown)

Richter's student works show his proficiency with such academic exercises (fig. 3). As students advanced into their major concentrations, studies from nature and the nude remained central within the coursework.[54] These measures satisfied the demand for "realism" coming from Moscow. In addition to the studio requirements, the early curriculum assigned four hours per week to the combined study of art history, sociopolitical history, and the history of literature and two hours per week to a class in perspective.[55] The school prescribed Marxist-Leninist teachings through mandatory faculty-led lectures devoted to "the political and social problems of today," and introduced Russian language instruction in 1949.[56]

Because of the prevailing suspicion of formalist artistic practices, the emerging canon at the Dresden Art Academy had a strong emphasis on classical and Renaissance models that predated both the "degenerate" art from the beginning of the century and the Nazi art that succeeded it. A formal vocabulary based also on 19th-century naturalism and the critical realism of early 20th-century art supplemented the classical periods, bringing them into the contemporary situation.[57] The curriculum further promoted Soviet Socialist Realism as an important corrective to both Nazi art and the offending modernist movements, following the same logic promoted by Hans Schulz's essay for the school catalogue.[58] German Realists like Wilhelm Leibl (p. 63) offered East Germans a nationalistic lineage that countered the emphasis on Russian forbearers such as Ilya Repin and the Wanderers, who were favored by the Soviets. No faculty members at the Dresden Art Academy actually practiced the blatantly didactic style of Soviet Socialist Realism, such as that of Alexander Gerasimov (1881–1963), president of the Soviet Academy of Arts from 1947 to 1957 and a frequent proponent of Soviet-style Socialist Realism in the GDR through its chief art publication *Bildende Kunst* throughout the 1950s. Instead, the faculty at the Dresden Academy generally produced what amounts to a pastiche of the certified prior styles. Simultaneous references to classical, Renaissance, realist, and modernist art typically were unified in a single picture by the emphasis on banal figuration and contemporary socialist subject matter. Richter's *Joy of Life* (1956), the only work from Richter's first decade as an artist in the GDR that has appeared with regularity in the literature, illustrates such a pastiche with references to Sandro Botticelli, Edouard Manet, and Max Beckmann readily apparent through the veneer of topical realism (fig. 4).[59]

Fig. 4 Gerhard Richter, *Joy of Life*, 1956. Mural. Deutsches Hygiene-Museum, Dresden (painted over)

Richter completed an earlier mural that offers a more telling picture of what might have counted for "resistance" for an ambitious young artist in the GDR. Entitled *The Supper,* it depicted a group of painters including Rembrandt, Leonardo da Vinci, Adolf Menzel, Angelica Kauffmann, Henri de Toulouse-Lautrec, and Picasso, among others, seated at a long table eating dinner.[60] He created it as a final project for his mural painting class in 1955. The mural was either removed or destroyed subsequent to its completion and only a fragment of what it looked like is available through a photographic detail that shows Toulouse-Lautrec toasting Mona Lisa (fig. 5). With the humorous inclusion of Mona Lisa among the seated guests, Richter anticipated certain works by Renato Guttuso, a leader of *Realismo* in Italy, such as the 1976 homage to Giorgio de Chirico set in a cafe (fig. 6). Painted well after Richter's *Supper,* Guttuso's *Caffè Greco* similarly contains the unlikely image of Buffalo Bill seated amidst the art-world guests. Guttuso's work inspired Jörg Immendorff's well-known series *Cafe Deutschland,* begun in 1978 (fig. 7). Immendorff reworked Socialist Realism in the West as a means to comment on Germany's divided history. In comparing Richter's admittedly sophomoric work to Guttuso's and Immendorff's mature examples, I am not asserting a mutual chain of influence that began with Richter. Rather, I would argue that the self-conscious and often arbitrary promotion of a politically certifiable canon in the GDR contained an inherent irony that could not help but be reflected in many works of the period, even if initially unintended.[61] Richter's painting is remarkable in its early intuition of the absurdity of a cut-and-paste

Fig. 5 Gerhard Richter: fragments from
The Supper, 1955.
Mural in the Art Academy dining room (destroyed)

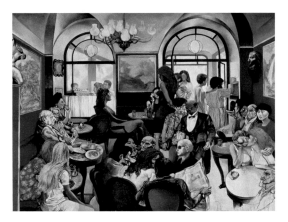

Fig. 6 Renato Guttuso, *Caffè Greco*, 1976.
Oil on canvas, 186 × 243 cm, Museum Ludwig, Cologne

Fig. 7 Jörg Immendorff, *Cafe Deutschland I*, 1978
Oil on canvas, 280 × 320 cm, Museum Ludwig, Cologne

canonical doctrine well before artists explored the effect more consciously.[62] Furthermore, the siting of the irreverent *Supper* in the school cafeteria underscores Richter's direct address of his immediate colleagues, as well as the young artist's wit. Subsequent developments in the work of other artists, such as Komar and Melamid and Neo Rauch, suggest later moments in a polemical genealogy of "resistance through irony" within the Soviet Bloc countries. Richter, of course, would have no part in such an illustrative reworking of Socialist Realism after his departure from the eastern republic. Nevertheless, the comical *Supper* remains an early, if isolated, reflection on the art historical program at the Art Academy that acknowledges the absurdity of received traditions.[63] When Richter was asked about the mural in 1994, he replied, "at least that one is still funny," indicating that he intended it to be humorous when he first painted it.[64]

In contrast to the incidental similarities between *Caffè Greco* and *The Supper,* Guttuso's political paintings from the 1950s directly inspired another mural by Richter in Dresden (figs. 8 and 9). Formerly located in the Socialist Unity Party headquarters in the heart of the city, Richter's painting depicted a "workers' uprising." The extant records of it include an underexposed photograph in Richter's private collection and some notes regarding the commissioning process held in the city archives in Dresden. What is perhaps most striking about the work is Richter's ease in assimilating Guttuso's muscular paint handling. The confrontation between the police and the workers captures great drama, particularly in the counterpoint of the woman lifting the flag and the fallen male protester at her side. Notably the mural avoids the rendering of a specific historical battle, though Elger has identified the policemen as wearing Weimar-era uniforms.[65] In contrast with the clumsiness of *The Supper,* and the tapestry-like conception of *Joy of Life,* the uprising integrates a complex figure group with greater bravado and confidence than the earlier murals. Although remaining figurative in conception, the departure in both subject matter and stylistic treatment from the prior works highlights Richter's ability to exchange modes of realism easily and perhaps arbitrarily. It also suggests that Richter never wed his work completely to any of the disparate historical models made available to him in the GDR.

Richter completed other mural projects in the GDR that remain beyond the scope of our present context. Though all are based in figuration, the range of techniques from a flatly painted geometrical application used in an outdoor mural (depicting energy resources along the eastern border) and a pointillist treatment for a proposed tile installation (on the subject of the *Tales of One Thousand and One Nights*) to the

Fig. 8 Gerhard Richter, *Workers' Uprising*, 1959. Mural (Socialist Unity Party headquaters, painted over)

gestural handling of *Workers' Uprising* indicates an openness to experiment that did not fit with the programmatic unity prescribed by Soviet and East German mandates. He also produced numerous drawings, paintings, and prints in his so-called "free work," which taken alongside the public commissions, constitute a substantial reckoning with the evolving artistic program under state socialism. Elsewhere I have proposed that Richter's collective output in the GDR constitutes a "shadow archive," in part because it is known primarily through photographs that Richter himself took for documentary purposes.[66] Most of the original works were destroyed or lost upon his resettlement. Yet the full contents of the shadow archive reveal his expressed desire to follow a "third path" between state socialism and capitalism.[67] He largely avoided adherence to a narrow ideological program, shifted his stylistic solutions to suit different settings, and retained a measure of idealism in the process. The avoidance of dogma inevitably compromised his work in the GDR, yet it also instilled in him a general distrust of artistic ideology that served him well in his particular reception of abstract painting in the West. Richter did not accept that gestural abstraction expressed the unmediated subjectivity of the artist as it was so often promoted in the polarized discourse of postwar painting in Germany. Furthermore, I would argue, his reliance on the camera to document *Informel* objectified the work and reinforced the second-hand quality of the encounter.

Shortly after Richter completed the mural for the party headquarters in 1959,

Fig. 9 Renato Guttuso, *The Battle of Admiral's Bridge*, 1951–52.
Oil on canvas, 321 × 521 cm. Private collection

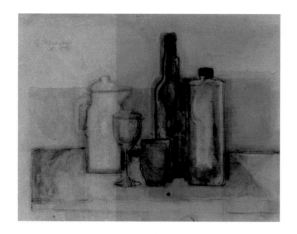

Fig. 10 Gerhard Richter, *Still Life*, 1959
Oil on cardboard, 52 × 64 cm, Private Collection

he traveled to West Germany to attend *documenta II* on a state-approved trip. His exposure to western art in Kassel often has been cited as one of the most important events that shaped his decision to leave the East German republic permanently in 1961. *Art informel* and *Tâchisme* dominated the European contributions alongside American works by Jackson Pollock and Robert Rauschenberg.[68] Richter's future teacher at the Dusseldorf Art Academy and a leader of German *Informel,* Karl Otto Götz, also had three works in the show.[69] Richter has stated that the artists Lucio Fontana, Alberto Giacometti, and Jean Fautrier in the exhibition (rather than Pollock and Rauschenberg, or Götz, for that matter) first attract-

ed his attention to a new way of working.[70] He was also intrigued by Giorgio Morandi's five still-life paintings on exhibit.[71] Between his return to Dresden after *documenta* and his decision to resettle in the West, Richter undertook a series of experiments over the next several months in response to what he had seen in Kassel. Some of these works included gestural paintings carried out in the spirit of *art informel,* as well as a few still-life paintings derived from Morandi's example (figs. 10, 11). For Richter, it would seem, both modes provided alternatives to Socialist Realism: *Informel* historically defied figuration as practiced in the GDR; Morandi's realism countered the didactic envisioning of a socialist future through its basis in empirical observation and use of banal objects. In terms of the prevailing opposition of "western" abstraction versus "eastern" realism promoted by the cultural leadership in both Germanys at the time, Richter's "divided" response took the dispersion of his own prior stylistic experimentation one step further. The proficient and simultaneous production of competing styles suggests an ideological neutrality remarkably similar to his later proclamation in the West that he was an artist with "no style."[72] Richter's provisional stance may not have constituted a full-scale critical practice in the GDR, but it did oppose doctrinaire Socialist Realism. The emergence of official state artists, such as Bernhard Heisig, Wolfgang Mattheuer, Willi Sitte, Werner Tübke, and Walter Womacka, would steer the course of art in the GDR in a decidedly more amalgamated direction[73] (see Tübke, p. 75). Singular styles emerged in the work of these well-known East German artists, yet the results are so compromised by the pressures of conformity that their works collectively represent nothing less than the rear guard of modernism in their allegiance to the state project of envisioning socialism, in whatever reformed version they individually contributed.

Fig. 11 Gerhard Richter,
Informel Studies, ca. 1960
Mixed technique on cardboard,
each 20 × 20 cm
(location unknown)

Table, 1962

This essay ends where most Richter studies begin, with the 1962 photo-painting *Table* (fig. 12). Richter incisively designated it as the first mature work in his catalogue raisonné of the paintings, despite the fact that it is neither the first successful painting in his œuvre nor the first photo-painting. By presenting an enlarged brushstroke over a photographically rendered table, the artist concisely determined the formulation of painterly and photographic illusionism that has played out in his œuvre with increasing complexity over the last 45 years.[74] As I have indicated, the earlier crisis of "how and what to paint" originated in Dresden and culminated in the dual explorations of *Informel* and the Morandiesque still lifes that he completed just before his move to the West. As Elger has documented, once Richter recognized that he could not work freely in such a fashion, he left the GDR permanently.[75] By that time, he had proven himself to be, at minimum, a gifted copyist whose solutions incidentally expressed well his avoidance of the ideological program in the GDR.[76] His photographic practice may have remained in the background of those efforts, but it already had conditioned his reception of art historical forebears.

As Richter underwent his reeducation at the Dusseldorf Art Academy, he increasingly understood *art informel,* as well as the succeeding trends of *Nouveau Réalisme,* Fluxus, and Op and Pop art so important to his subsequent development, as equally worthy of exploration. In the process he treated the contending movements with an even hand and, perhaps, with the photographic eye that he first developed in the GDR. He would reject styles as quickly as he found them, and later return to the rejected work in new series. Yet while discrete series of abstract paintings, monochromes, portraits, landscapes, or color charts show developmental continuity across the temporal interruptions in his œuvre, he would never recover the innocence of an adolescent watercolor like *Moonscape*. Instead the breaks themselves become a major subject of the work and ideological avoidance, first explored in the GDR, their justification.

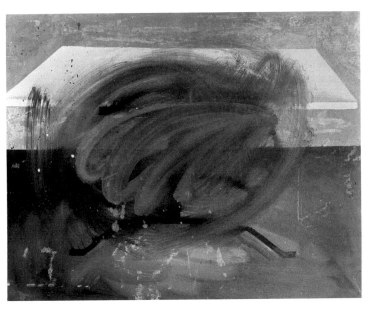

Fig. 12 Gerhard Richter, *Table*, 1962.
Oil on canvas, 90 × 113 cm.
On loan from a private collection to the San Francisco Museum of Modern Art

Notes

Please note that Richter's student files are held by the Archive of the Hochschule für Bildende Künste (AHfBK). The records are not numbered individually in that collection. All log numbers used in the footnotes refer to the author's log and copies of those records. The author would like to thank Gerhard Richter for permission to review and publish these documents. The author must also thank Christine Poggi, Robert Ackerman, Mark Levitch, and Nicholas Sawicki for their comments on earlier drafts of this essay. Here I have begun to outline some of the key issues and research findings presented more fully in my dissertation; see Nugent, Jeanne Anne: "Family Album and Shadow Archive: Gerhard Richter's East, West and 'All' German Paintings, 1949–1966," Ph.D. Thesis, The University of Pennsylvania, 2005.

1 Butin, Hubertus: "The Un-Romantic Romanticism of Gerhard Richter," in: *The Romantic Spirit in German Art, 1790–1990,* exh.cat., (trans.) David Britt, London: Thames and Hudson, 1994, pp. 461–463. For a discussion of the distancing effects of Richter's landscapes obtained largely through the camera, see the essays in Elger, Dietmar (ed.): *Gerhard Richter: Landscapes,* Ostfildern-Ruit: Cantz, 1998.

2 Butin: "Un-Romantic Romanticism," p. 462.

3 Gerhard Richter has previously titled other works *Wald,* which has sometimes been translated as *Forest.* I prefer the translation of *Woodland* because of its more poetic resonance. Richter himself proposed *Woodland* in reference to the new series; e-mail correspondence between Gerhard Richter and the author, 24 May 2006.

4 These works were first shown under the title *Abstrakte Bilder* at the Marian Goodman Gallery New York (Nov. 17, 2005 – Jan. 14, 2006).

5 Richter, Gerhard: "Benjamin H. D. Buchloh / Gerhard Richter, Interview, November 2004," in: *Gerhard Richter: Paintings from 2003–2005,* exh.cat., Cologne: Walther König, 2005, p. 62.

6 Ibid.

7 I am referring not only to the Stasi surveillance of the citizenry but also to the state's complete control of the press. An investigation of the Stasi's role in the East German art academies would

be a great asset to interpretations of artistic developments in the GDR. To my knowledge no one has yet researched this connection as it might relate to East German artistic production. Ulrike Goeschen has examined the development of Socialist Realism in East Germany with a particular emphasis on the reception of modernism; she uses considerable archival evidence to show the role of governmental agencies in monitoring artistic developments and of artists who operated within the institutional hierarchies; see Goeschen, Ulrike: *Vom sozialistischen Realismus zur Kunst im Sozialismus,* Berlin: Duncker & Humblot, 2001.

8 Buchloh, Benjamin: "Ready-made, photographie et peinture dans la peinture de Gerhard Richter," in: *Gerhard Richter,* exh.cat., Paris: Centre national d'art et de culture Georges Pompidou, Musée nationale d'art moderne, 1977; translated in Buchloh, Benjamin: "Readymade Photography, and Painting in the Painting of Gerhard Richter," in: *Neo-Avantgarde and Culture Industry: Essays on European and American Art from 1955 to 1975,* Cambridge, Massachusetts: The MIT Press, 2000, pp. 365–403. Richter has emphasized that he came to understand the concept of the readymade first through the work of Andy Warhol and Roy Lichtenstein, and that he did not see Duchamp's work in person until 1965 on the occasion of a retrospective in Germany. By then he had nearly completed his first series of photo-paintings. See Elger, Dietmar: *Gerhard Richter, Maler,* Cologne: Dumont, 2002, p. 144. Although Richter responded directly to Duchamp's work in a few specific photo-paintings after 1965—*Toilet Paper* (three versions, 1965) and *Nude on a Staircase (Ema)* (1966)—I would argue that the color charts were the first series that directly engaged the readymade principle and more profoundly directed Richter's work thereafter.

9 Peter Bürger first used the term "neo-avant-garde" to unite the work of a generation of international artists from the late 1950s and 1960s, and to engage their work dialectically with the earlier generation of the "classical avant-garde" from the 1910s and 1920s. See Bürger, Peter: *Theory of the Avant-Garde,* (trans.) Michael Shaw, Minneapolis: University of Minnesota Press, 1984. Bürger viewed the work of the neo-

avant-garde as inferior to the more radical efforts of the "classical" generation. Buchloh reworked Bürger's dialectical model and countered instead that the neo-avant-garde strategies of appropriation engaged history critically and positively. Compare Buchloh, Benjamin: "Theorizing the Avant-Garde," in: *Art in America* 72 (November 1984), pp. 19–21.

10 Richter traveled to Brussels, Paris, Kassel, and Hamburg, as well as to St. Petersburg and Moscow, on state-sponsored trips while associated with the Dresden Art Academy. His teacher, Heinz Lohmar, vouched for his return and provided permission letters; Elger, Dietmar: *Gerhard Richter, Maler,* p. 39. See also Richter's comments on the subject in my interview with him in this catalogue.

11 Huyssen, Andreas: *After the Great Divide: Modernism, Mass Culture, Postmodernism,* Bloomington and Indianapolis: Indiana University Press, 1986.

12 Haftmann, Werner: "Malerei nach 1945," *II. documenta '59, Malerei,* Cologne: Dumont, 1959, pp. 12–19.

13 Rosenblum, Robert: *Modern Painting and the Northern Romantic Tradition: Friedrich to Rothko,* New York: Harper and Row, 1975; Rosenblum, Robert: "A Postscript: Some Recent Neo-Romantic Mutations," in: *Art Journal* 52/2 (Summer 1993), pp. 74–84.

14 Robert Rosenblum does mention Richter in his book, however, he does not develop the "Romantic" allusion either in reference to a contemporary West German context or in connection with the Dresden Art Academy in the GDR. See Rosenblum, *Modern Painting and the Northern Romantic Tradition.*

15 Dieter Schwarz most recently has claimed that Richter's abstract paintings cannot be instrumentalized; see Schwarz, Dieter: "The Turn of the Screw," in: *Gerhard Richter: Paintings from 2003–2005,* p. 113. For a discussion of Richter's historicism in relation to abstract painting, see Fer, Briony: *On Abstract Art,* New Haven and London: Yale University Press, 1997, pp. 154–162; and compare Buchloh, Benjamin: "Pandora's Painting: From Abstract Fallacies to Heroic Travesties," in: *Gerhard Richter Documenta IX,* New York: Marian Goodman Gallery, 1993, especially pp. 47–48.

16 Two recent studies that begin such reconciliation are Boym, Svetlana: *The*

Future of Nostalgia, New York: Basic Books, 2001; and Buck-Morss, Susan: *Dreamworld and Catastrophe: The Passing of Utopia in East and West*, Cambridge, Massachusetts, and London: The MIT Press, 2002.

17 Jürgen Harten was one of the first authors to align Richter's painting with Romanticism; see Harten, Jürgen: "Der romantische Wille zur Abstraktion," in: Harten, Jürgen (ed.): *Gerhard Richter Bilder 1962–1985*, Cologne: Dumont, 1986, pp. 9–61; Robert Storr follows Rosenblum's model of a recuperable history of German Romanticism though formal comparisons with Friedrich's work; see Storr, *Gerhard Richter: Forty Years of Painting*, New York: The Museum of Modern Art and D.A.P., 2002, especially pp. 65–71.

18 Richter, Gerhard: "Text for catalogue of *documenta 7*, Kassel," in: *The Daily Practice of Painting: Writings 1962–1993*, Cambridge, Massachusetts: The MIT Press, 1998, p. 100.

19 Elger, Dietmar: *Gerhard Richter, Maler*; see also Schreiber, Jürgen: *Ein Maler aus Deutschland*, Munich and Zurich: Pendo, 2005.

20 For more on Richter's father, see Elger, *Gerhard Richter, Maler,* pp. 10–13.

21 Ibid., p. 14.

22 Gerhard Richter: "Lebenslauf," 1951, in the student files of Gerhard Richter (log 27jn).

23 Ibid.

24 Elger, Dietmar: *Gerhard Richter*, p. 13.

25 "Abschlusszeugnis," Wirtschaftsschule Zittau; in the student files of Gerhard Richter (log 29jn).

26 Lillig is not identified in Elger's biography. I am grateful to Gerd Goldberg, a family friend of Lillig, for identifying Hans Lillig and providing some photographs of Lillig's work from the late 1940s; Gerd Goldberg in conversation with the author, 15 July 2004, Waltersdorf.

27 Extant black and white photographs of Lillig's mural are of poor quality and not suitable for reproduction.

28 During the Soviet occupation of the northeastern sector of Germany from 1945 to 1949, the Soviet authorities expropriated private libraries and collections, making a body of art and literature available to the public. With the founding of the East German Republic in 1949, new restrictions emerged to limit public access to works

of art, music, and literature deemed "formalist."

29 Richter, Babette: "Glauben: Gespräch mit Gerhard Richter," in: *Der Andere: Interviews–Versuch einer Annäherung*, Cologne: R&B, 2002, p. 45.

30 Elger, Dietmar: *Gerhard Richter, Maler*, p. 14.

31 Gerd Goldberg in conversation with the author, Waltersdorf, 15 July 2004.

32 Richter, Gerhard: "Letter to Jean-Christophe Ammann, February 1973," in: *Daily Practice*, p. 81.

33 Richter, Gerhard: "Interview with Jonas Storsve, 1991," in: *Daily Practice,* p. 230.

34 Letter from Gerhard Richter to the Hochschule für Bildende Künste, 31 May 1951, in the student files of Gerhard Richter (log 28jn).

35 Storr: unpublished interview with Gerhard Richter, 2001; quoted in: *Forty Years,* p. 20.

36 Richter, Gerhard: "Gedanken zur Situation der Kunst," 1951; in the student files of Gerhard Richter (log 30jn).

37 *Hochschule für Bildende Künste Dresden: Personal- und Vorlesungsverzeichnis Studiengang*, Dresden: AHfBK, 1951, p. 5.

38 Richter: "Gedanken zur Situation der Kunst," 1951, p. 1.

39 Many of the key documents of the formalist debates in Germany can be found in *Abstraktion im Staatssozialismus: Feindsetzungen und Freiräume im Kunstsytem der DDR,* (eds.) Rehberg, Karl-Siegbert and Paul Kaiser, Weimar: VDG, 2003.

40 Orlow, N.: "Wege und Irrwege der modernen Kunst," in: *Tägliche Rundschau* 21 (Part I: January 21, 1951; Part II: January 23, 1951); reprinted in: *Abstraktion im Staatssozialismus,* pp. 303–307; "N. Orlow" was a pseudonym. Speculation as to the real author includes the names of Vladimir Semjonov, Kurt Magritz, or the collective authorship of Kurt Magritz and Kurt Liebknecht, Ernst Hermann Meyer, and Georg Knepler, all members of the cultural leadership; Karl-Siegbert Rehberg has speculated that the name of "Orlow" may have been a "wandering pseudonym" that generally stood for the legitimized position of the Soviet Military Administration during the formalism debate; see "Die verdrängte Abstraktion: Feind-Bilder im Kampfkonzept des 'Sozialistischen Realismus,'" in: Ibid., p. 33, n. 33.

41 Ibid. Picasso was a controversial figure within the Soviet Bloc countries. The

Soviet leadership generally disapproved of works like *Guernica* and *The Massacre at Korea* because of the distortion of the human form within them, despite the anti-imperialist message. Yet for artists, including Richter, who wished to engage "western" modernism, the Communist Picasso seemed a suitable alternative to the Soviet artists. The controversy culminated in the so-called "Picasso debate" of 1955 to 1956, which took place in the pages of *Bildende Kunst*. The East German debate coincided with the first touring retrospective of Picasso's work in West Germany. See *Picasso. 1900–1955,* exh. cat., essays by Jardot, Maurice and Alfred Hentzen, (trans.) Friedhelm Kemp, Munich: Haus der Kunst, 1955. Picasso's graphic works were exhibited in East Berlin the following year. See *Pablo Picasso. Das Graphische Werk,* exh. cat., essay by Kahnweiler, Henry-David, Berlin-Ost: Nationalgalerie, 1957. The debate is treated in light of Richter's work in Nugent, "Family Album and Shadow Archive," pp. 66–75.

42 Richter: "Gedanken zur Situation der Kunst," p. 3. Compare Hermlin, Stephan: *Die jungen Künstler - das Alte und das Neue. Das große Referat von Nationalpreisträger Stephan Hermlin auf dem Kongress junger Künstler*, Berlin: Neues Leben, 1951.

43 Richter: "Gedanken zur Situation der Kunst," p. 3.

44 For a useful summary of Socialist Realism's stylistic shifts in response to political events in East Germany, see Damus, Martin: *Malerei der DDR: Funktionen der bildenden Kunst im Realen Sozialismus*, Reinbeck bei Hamburg: Rowohlt, 1991.

45 Schulz: "Zur Geschichte der Hochschule," *Personal- und Vorlesungsverzeichnis*, pp. 3–8.

46 Ibid., p. 6.

47 Ibid., p. 7.

48 Ibid., p. 8.

49 *Dresden: Von der Königlichen Kunstakademie zur Hochschule für Bildende Künste*, Dresden: VEB Verlag der Kunst, 1990, p. 417.

50 Quoted in Sager, Peter: "Mit der Farbe denken," in: *ZEITmagazin,* 28 November 1986, p. 3.

51 *Dresden: Von der Königlichen Kunstakademie*, p. 413.

52 Ibid.

53 Ibid.

54 Ibid.

55 Ibid.

56 Ibid., pp. 415–16.

57 Ibid., p. 428.

58 "Grundstufe Bildende und Ange-wandte Kunst im künstlerischen Volksschaffen (Malerei und Grafik) Lehrplan und Erläuterung," AHfBK, 03/406.

59 For example, compare Flacke, Monika (ed.): *Auftrag: Kunst 1949–1990: Bildende Künstler in der DDR zwischen Ästhetik und Politik*, Berlin: Deutsches Historische Museum, 1995; Storr, *Forty Years*; Guth, Peter: *Wände der Verheissung: Zur Geschichte der architekturbezogenen Kunst in der DDR*, Leipzig: Thom, 1995.

60 A handwritten note by Professor Klotz of the Dresden Art Academy identifies Leonardo, Rembrandt, Angelica Kauff-mann and Menzel; that memo men-tions the loss of the mural when a wall was broken through during reno-vations of the kitchen and speculates that it might have been removed and preserved; "Erinnerungen von Prof. Klotz," 27 June 2003, AHfBK. Picasso is mentioned as one of the artists by Jörg Schneider in an interview with Gerhard Richter/Jörg Schneider: "Richters Jugendsünde wird freigelegt," in: *Dresdner Morgenpost*, 6 September 1994, p. 9.

61 For example, Peter Guth has comment-ed that a kind of "mural painting fatigue" had set in among the general public as early as the 1950s, which was manifest in a number of jokes about public art. See Guth: *Wände der Verheissung*, pp. 7, 390.

62 Richter's portrait of Toulouse-Lautrec resembles José Ferrer more than Toulouse-Lautrec, indicating that the artist may have seen John Huston's 1952 film *Moulin Rouge,* or at least the pub-licity surrounding its release. I am grateful to Kenneth Silver for recently calling the resemblance to my atten-tion. Christopher Lee photographed Ferrer with Huston for Magnum Photos in 1952. Richter received copies of the West German edition of the magazine *Magnum* in the mail from a relative in the West in the 1950s. See Elger: *Gerhard Richter, Maler*, p. 22. I discuss Richter's use of Pop sources in East Germany in Nugent, "Family Album and Shadow Archive," pp. 21–23, 99–100, 169–180.

63 Richter has treated the subject of a canonical cultural tradition in his mature work. The 1998 print edition entitled *Survey* presents five categories of intellectual achievement—fine arts, architecture, music, philosophy, and literature—through discrete parallel bands arranged by discipline. Richter charts the names of major cultural figures from Praxiteles to Dan Graham according to birth and death dates in the ostensibly objective manner of an art history table. Richter includes him-self and his second wife, Isa Genzken, along with contemporaries Joseph Beuys, Blinky Palermo, and Sigmar Polke in the grouping, which defeats the dry factual objectivity associated with such presentations. The inclusion of his associates may seem a vain or perhaps humorous gesture, but it also attests to Richter's belief in the necessi-ty of carrying forth a cultural heritage through contemporary practices. See Schwarz, Dietmar: *Gerhard Richter: Survey*, Cologne: Walther König, 2001.

64 Schneider: "Richters Jugendsünde wird freigelegt," p. 9.

65 Elger: *Gerhard Richter, Maler*, p. 28.

66 Nugent: "Family Album and Shadow Archive."

67 Richter, Gerhard: "Benjamin H.D. Buchloh/Gerhard Richter, Interview", (note 5), pp. 132–33.

68 *II. documenta '59, Kunst nach 1945, Band I, Malerei,* exh.cat., Cologne: Dumont, 1959.

69 Ibid., p. 176. Richter first studied with Ferdinand Macketanz at the Dusseldorf Art Academy, but switched into Götz's class after his first year; Elger: *Gerhard Richter, Maler*, p. 47.

70 Richter, Gerhard: "Benjamin H.D. Buchloh/Gerhard Richter, Interview", (note 5), p. 133.

71 *II. documenta '59*, p. 276.

72 Richter, Gerhard and Sigmar Polke: "Text for an exhibition catalogue, Galerie h, Hanover, 1966," in: *Daily Practice,* pp. 42–43.

73 For a recent reassessment of these artists' contributions, see Blume, Eugen and Roland März: *Kunst in der DDR: Eine Retrospektive der Nationalgalerie,* exh.cat., Berlin: Berlin Verlag, 2003. Although some of these artists suffered reprisals from the government when they strayed from acceptable standards, they also enjoyed considerable privileges as cultural leaders.

74 The source for the painting, a photo-graph of a designer's table taken from a magazine in which Richter painted over the reproduction, similarly initi-ates the play between reference and work that finds greater multiplicity in the *Atlas* and the various catalogues raisonnés. For an introduction to the complexity of photographic references in the artist's work, see the essays in: *Photography and Painting in the Work of Gerhard Richter: Four Essays on Atlas,* exh.cat., Barcelona: Actar, 2000.

75 Elger: *Gerhard Richter, Maler*, p. 41.

76 It is important to emphasize that the ideological program in the GDR was a work in progress throughout the Cold War. The cultural leadership constantly changed the rules to suit different social and political objectives, resulting in works that attempted to reconcile new imperatives with earlier, and con-tradictory, policies. It is difficult to assess how unique Richter was in trying to dodge the dominant models of Socialist Realism because this aspect of art in the GDR is little studied. Given his subsequent production in Dussel-dorf, however, Richter's range of solutions in the GDR is significant in terms of his avoidance of ideology and its consequence on his work after resettlement.

JEANNE ANNE NUGENT

Gerhard Richter's "Woodlands"
and Other Things of the Past

> A painting by Caspar David Friedrich is not a thing of the past.
> What is past is only the set of circumstances that allowed it to
> be painted: specific ideologies, for example. Beyond that, if it
> is any 'good,' it concerns us—transcending ideology—as art that
> we consider worth the trouble of defending (perceiving,
> showing, making). It is therefore quite possible to paint like
> Caspar David Friedrich "today" (Gerhard Richter, 1973).

When standing before any of Gerhard Richter's paintings, the impulse to look beyond the work-at-hand and consider the specific conditions of its exhibition is more than a temptation—it is practically a necessity. While this may be true for any artist's work, in Richter's case the deliberate structure of his œuvre has trained our eyes to see past the particular image before us. Each work reverberates, whether with nature, art, or the daily newspaper. One cause for this response has to do with Richter's purposeful organization of his entire body of work within the many archival systems that he himself has devised, such as the *Atlas* project, several catalogues raisonnés, photographic editions of paintings, and multiples. All of these collections encourage readings across one another and complicate the issues of source, reference, theme, variation, style, genre, and subject so often used to analyze his diverse production.

The visual interplay among works also arises from the way Richter hangs the paintings. At the heterogeneous 1996 installation of *100 Pictures* at the Carré d'Art in Nîmes, for instance, Richter displayed a few examples of works from several discrete series including the Mirrors, Abstract Paintings, Color Charts, and Photo-Paintings (comprising portraits, still lifes, and landscapes).[1] This exhibition encouraged viewers to look beyond the narrow classifications Richter has used to name his works and oriented them toward a more variable situation contingent upon unexpected juxtapositions across typologies. At other times the work retains its status as a unified cycle, such as *Wald, 1–12* presented here within the historical framework of a German painting tradition. The *Wald* series serves as a pendant to Friedrich's landscapes through the symmetrical hanging of the works in adjoining galleries, and thus speaks again across different categories, though here articulated by the chronology initiated by Friedrich and ending with Richter. The visual balance of the arrangement and the larger number of works by Friedrich and Richter relative to the other artists lends them equal status—one that is amplified further by their shared iconoclasm. Friedrich famously alarmed contemporary critics by infusing landscape with religious ideals, as exemplified by *The Cross in the Mountains (Tetschen Altar)* (p. 35). Richter similarly challenged the fixity of historical genres through the extreme variation of

his œuvre. Moreover, Richter's engagement with history through shifting settings has been remarkably hands-on: the artist has produced scale models for nearly every installation—including this one—featuring his work.

Richter acquired his model-building skill as an aspiring mural painter at the Dresden Art Academy, where Friedrich also was associated as a teacher. In Dresden, Richter too first confronted ideology. During the Nazi era, Romantic art and music had been notoriously put in the service of Aryan propaganda. Later in East Germany, Socialist Realism attempted to reclaim the long history of mural painting from the Renaissance masters to the Mexican muralists under the imperative of envisioning State Socialism as a powerful and beneficent presence; meanwhile the Soviet standard of a progressive Socialist Realism was intended to rectify the rupture of the Nazi project by anchoring contemporary art within a more noble history. This latter context of East German Socialist Realism accounts for the "specific ideology," to paraphrase Richter's statement concerning Friedrich, that brought Richter's earliest public works into being in the form of murals created in Dresden. Most of his solutions from that era were not "good" in the aesthetic sense that Richter later posited when writing about Friedrich. Yet Richter's desire to "transcend ideology" originated in East Germany and has persisted alongside the artist's concern for architecture in directing our vision toward painting's ongoing viability in the face of historical upheaval.

Today, abstract painting is but one among myriad options in a greatly expanded field of artistic endeavor that includes installation art, Conceptualism, and site-specific work—practices that largely arose in opposition to painting's postwar dominance in the visual arts. Despite Richter's singular devotion to painting, his prolific output over the years nevertheless has contributed significantly to art's expansion, and, paradoxically perhaps, reopened the possibility of abstract painting in a way that acknowledges the dynamics of contemporary art practice.[2] For some authors, his abstract paintings amount to the last breath of a nearly exhausted postwar genre; for others, Richter's engagement with abstraction represents a triumphal return.[3] However, such "medium-specific" interpretations suspend "abstract painting" as an autonomous field without taking full advantage of the cross-fertilization of genres and mediums that the artist's greater body of work encourages. Richter's statement that "any abstract daubings can be easily reconciled with a realistic photograph," and his clarification of those "two illusionistic modes" as "the photographed reality and the real color traces," provides a constructive way to narrow down Richter's particular contribution to painting's history that relates well to our present context. His comments serve as a bridge between his "photographic" interests in Friedrich and the abstraction presented by the *Wald* series. In particular, the shared blurring effects in both series serve as the baseline technique that unites them.

Were it not for our knowledge of Richter's deployment of style categories as a mode of expression in itself and his installations of works that interrogate stylistic periodization, one might conclude that the pairing of Richter's abstract works with Friedrich's landscapes uncritically elides history. What happens instead is an historical provocation of a different sort. The shared title of *Wald* associates the works with the subject of many of Friedrich's landscapes. Yet rather than depending upon the photographic appropriation of trees and a low horizon line, they instead inscribe the photographic trace of the blur within the conventions of postwar abstraction. As a

result, the *Wald* series comes closer to attaining the mysterious chill that infuses Friedrich's meditations on nature than the mere citation of a recognizable topography might. Richter's paintings achieve this expressive condition in part by enlarging the function of the blur, a painterly effect that nonetheless here retains its metaphoric associations with photography; in particular, the lack and variation of focus, the frailty suggested by a shaky camera, and the motion of time-lapse exposure all become spatial devices that might be found in the abstract works without reference to an actual photograph. These effects represent one way in which metaphoric allusions to the forest emerge with greater subtlety in the *Wald* series.

In calling attention to the ways in which Richter's paintings speak across history and mediums (here photography), I am neither suggesting that the new abstractions lack their own expressive resonance, nor that individual works must rely on the construction of Richter's entire œuvre to find meaning. Because the suite of paintings is uniform in size and means of production, it sustains a self-reflexive reading that gives the entire group its harmonious effect. The vertical format of the canvases roughly conforms to the arms' reach of the artist, which also lends the work a human scale. Richter loads a large squeegee with paint and drags it across the canvas in a repeating pattern of horizontal and vertical strokes. The surface thereby accumulates a material density compositionally anchored by the network of roughly perpendicular swaths of paint. With each coat, small bits of underlying pigment occasionally disperse themselves in blips and blobs that interrupt the monotonous rhythm of the technique. The physical movement of the squeegee is highlighted by these flecks of color, which mimic the traces of light found in time-lapse photography. This seemingly minor photographic note is just one way that Richter's "two illusionistic modes" find a dual resonance in the paintings. By varying the pressure of the hand and the saturation of the various pigments, the paint further acquires a visual depth that works against the flatness of the underlying geometry. At times, Richter also removes paint from the filmy deposit by scraping wide bands or minute scratches of pigment to reveal contrasting colors underneath it, intensifying the play between figure and ground.

Two paintings better illustrate the subtleties in the allusive play of the series as a whole. *Wald, 8* is one of the darkest paintings in the group (p. 108). Three floating balloon-like blotches are reminiscent of Mark Rothko's paintings from around 1950, except, importantly, that the opacity of Richter's material stands in contrast to Rothko's translucency. The congealed aspect of the dark brownish-purple oil paint that defines the three main fields makes the work decidedly earthbound. Like the other abstractions in the series, horizontal and vertical bands of overlapping colors impose a loose grid on the canvas. Here, however, the painting tool stops and starts, thus leaving gaps in the sweep of the gestures that record themselves as long straight lines in the surface. The fragmentary effect gives the work a tentative quality linked to the artist's hand. However, it also resembles a multiply exposed photograph in its emphatic reiteration of an outline. Toward the center of the canvas, a few downward strokes made with a thick brush evoke gravity. If it were a rainstorm (and it is not), it would be the kind that soaks to the bone and disorients one's vision while passing through a hypothetical tangle of trees. More brilliant colors pop through the snarl of darker pigment in isolated shimmers of light, such as the cadmium yellow that bursts forth on the lower left, or the red and green that seem to bleed through the back-

ground and stain the surrounding layers. Because the painting is abstract, no single association comes to the fore; instead the effects of staining, tamping, raining, bleeding, and blurring all combine to evoke the gloomier attributes of a sunless forest.

Wald, 12 is arguably the coolest and most serene painting of the series (p. 112). Because of the silvery palette it comes closer in mood to some of Friedrich's works such as *Monk by the Sea* or *Sea of Ice*. Drifts of white paint illuminate the entire surface in patches that might designate snow both in its material accumulation and as a blinding element encountered when observing a fresh snowfall. Here the squeegee digs into the piled-up layers of gray and white paint revealing long vertical slivers of orange, red, and sap green underneath. The assembly might read like a stand of barren trees receding away from the viewer. Alternately they appear like Barnett Newman's "zips," such as those found in the monumental *Vir heroicus sublimis* of 1950–1951, except that Richter's work again allows painterly illusionism to defeat the flatness of his ground. Additionally, a gray haze over the entire top half of Richter's canvas bisects the view and further suggests a veiled window. In evaluating its visual impact, one might link the effect to Richter's parallel interest in reflection and deflection manifest in the several glass, window, and mirror installations that he has executed over the years. Instead, I prefer to return to Friedrich, though this time to an interior like *Woman before a Window*, where a psychological interiority is defined against the world outside the window that frames nature in the distance. Within the gauzelike screen of gray over the top, one discerns a smaller rectangle of lighter gray that minimally echoes the dimensions of the entire painting, or it may be read as a window within the window of the canvas support itself. In either case, the doubling aspect holds vision at bay and distances the viewer from both nature and abstraction as they are fused within the work.

Tradition is always partly a thing of the past. What brings it into the present is its capacity to address contemporary concerns. Richter's traditionalism may center simply, though importantly, on the fact that he never abandoned architecture as a primary vehicle for the display of his work. Whether a government building, museum, church, or gallery, Richter's attention to the space of the viewer within culturally significant sites remains consistent and remarkable. The monumental glass panels of *Red, Black, Gold* in the foyer of the Berlin Reichstag (1999), the more recent installation of the 30-foot-high tiled photograph *Strontium* at San Francisco's renovated de Young Museum (2005), and the stained-glass window currently under construction for the Cologne Cathedral all attest to Richter's ability to create work that defends tradition even as the work itself reflects and transforms it. It is impossible to say that Richter, or anyone, has "transcended ideology," but he certainly has overcome the ideological framework that strove to confine his practice.

Notes

1 Obrist, Hans Ulrich (ed.): *Gerhard Richter: 100 Pictures,* (texts) Birgit Pelzer and Guy Tosatto, Ostfildern-Ruit: Cantz, 1996. The exhibition in the Carré de Nîmes was not the first instance in which Richter presented diverse works in one exhibition. However it was one of the more intimate presentations and included a rare self-portrait, portraits of family members, smaller scale still lifes, and landscapes, alongside the Mirrors and Color Charts. Klaus Honnef was the first to discuss Richter's breaks in style as an expressive device in its own right on the occasion of a similarly heterogeneous retrospective in 1969, see "Schwiergkeiten beim Beschreiber der Realität. Richter's Malerei zwischen Kunst und Gegenwart," in: *Gerhard Richter,* exh.cat. Aachen: Gegenverkehr, 1969, unpaginated.

2 Richter has created works in other mediums, including sculpture, photography, and conceptual installations, though painting remains the predominant medium with nearly 2500 examples now documented in his catalogue raisonné.

3 Richter himself recently characterized his work as "the last flicker of postwar painting"; see "Benjamin H. D. Buchloh/Gerhard Richter, Interview, November 2004," in: *Gerhard Richter: Paintings from 2003–2005,* exh.cat., Cologne: Walther König 2005, p. 69. Benjamin Buchloh largely focuses on the historical liquidation of painting in his postwar history of art; he views Richter's work as a demonstration of that liquidation; for an introduction to his dialectical framing of postwar art (1955–1975) that emphasizes World War II's rupture of artistic traditions in the 20th century, see Buchloh, Benjamin H. D.: *Neo-Avantgarde and Culture Industry*, London, England and Cambridge, Massachusetts: The MIT Press, 2000. Robert Storr follows Rosenblum's model of a recuperable history of German Romanticism less concerned with rupture though formal comparisons with Friedrich's work; see Storr, Robert: *Gerhard Richter: Forty Years of Painting,* New York: The Museum of Modern Art and D. A. P., 2002, especially pp. 65–71. For a summary of these two authors' positions within the context of the reception of Richter's work in the United States, see Nugent, Jeanne Anne: "The American Apotheosis of Gerhard Richter," in: *The Art Book* 10 (March 2003), pp. 11–13.

Gerhard Richter

b. 1932 in Dresden

Wald 2005
A series of 12 paintings
Oil on canvas, each 197 × 132 cm

Wald (892-1, -7, -9), 2005
Collection of Mitzi and Warren Eisenberg
Promised gift to The Museum of Modern Art, New York

Wald (892-2, -5, -6, -8, -10, -12), 2005
Collection of The Museum of Modern Art, New York
Gift of The Susan and Leonard Feinstein Foundation and The Mitzi and Warren Eisenberg Family Foundation

Wald (892-3, -4, -11), 2005
Collection of Susan and Leonard Feinstein
Promised gift to The Museum of Modern Art, New York

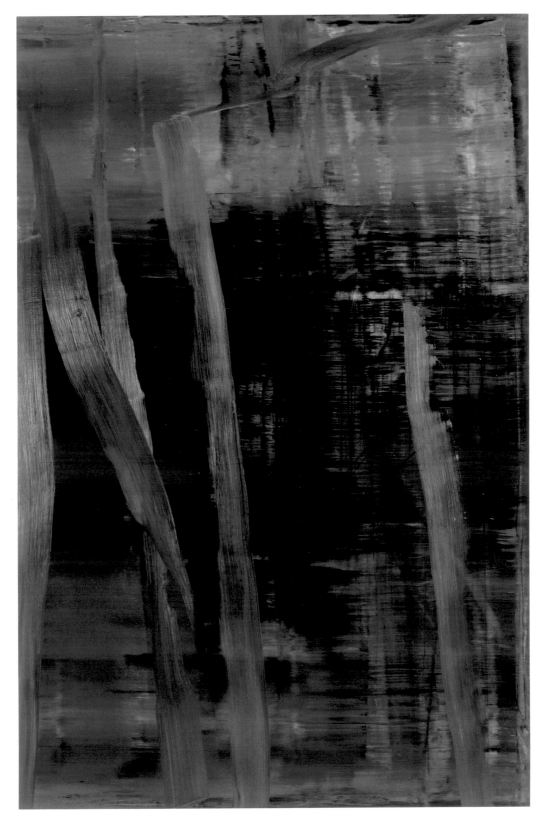

Wald (1)

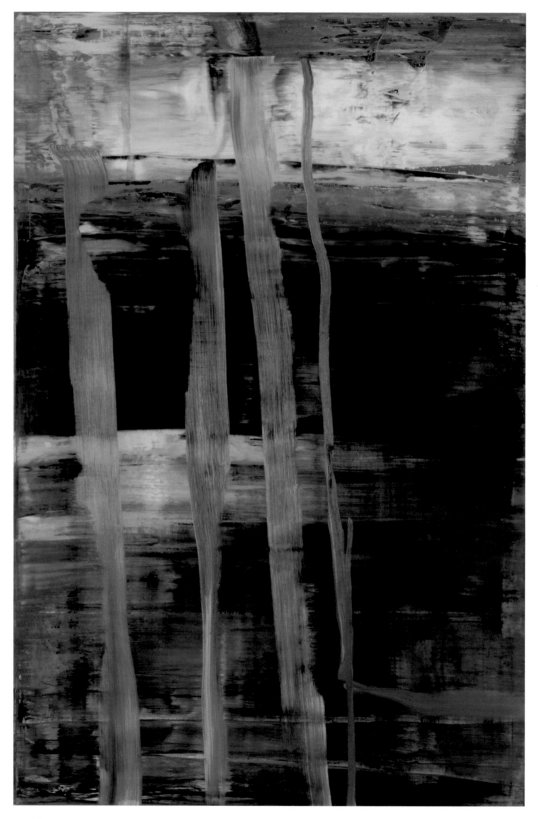

Wald (2)

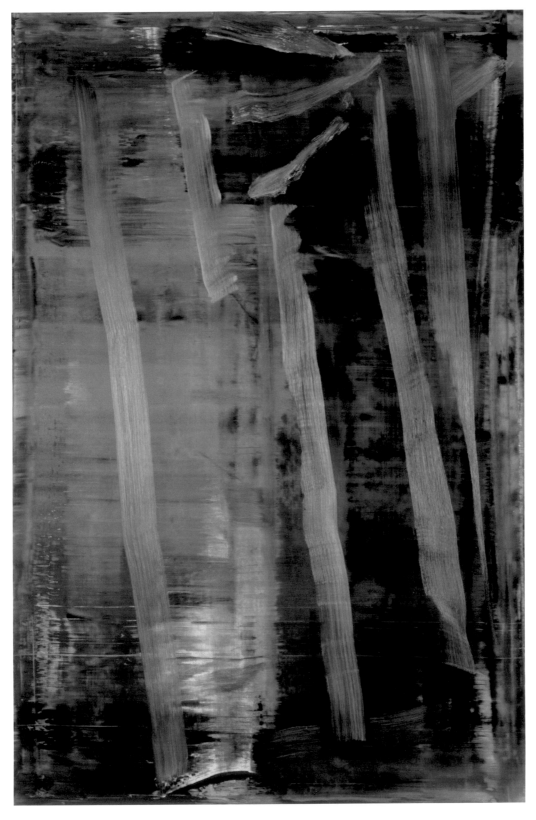

Wald (3)

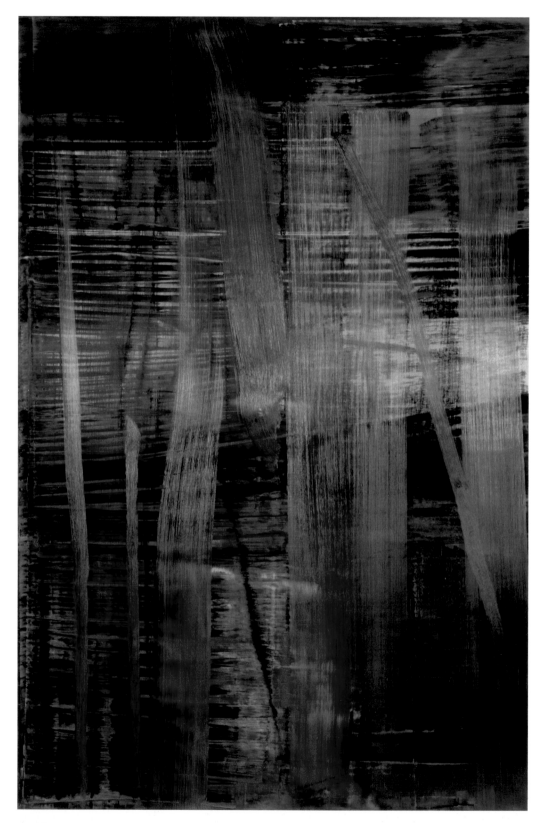

Wald (4)

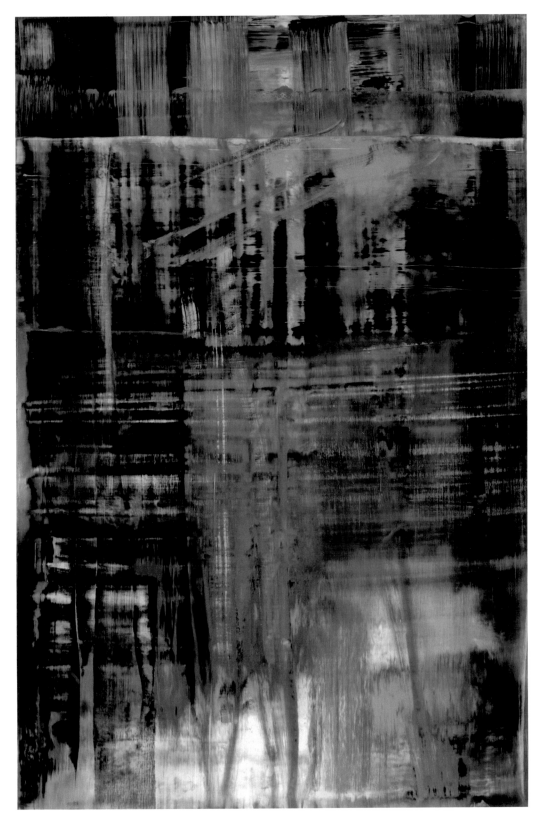

Wald (5)

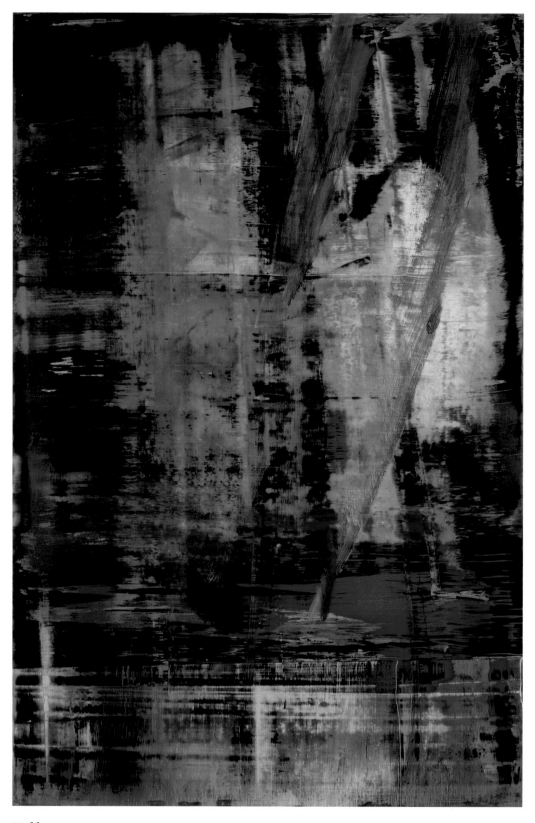

Wald (6)

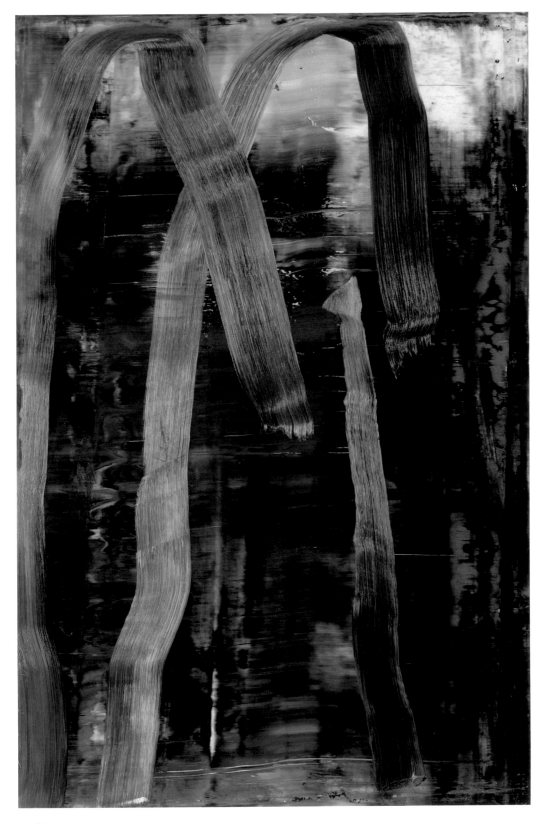

Wald (7)

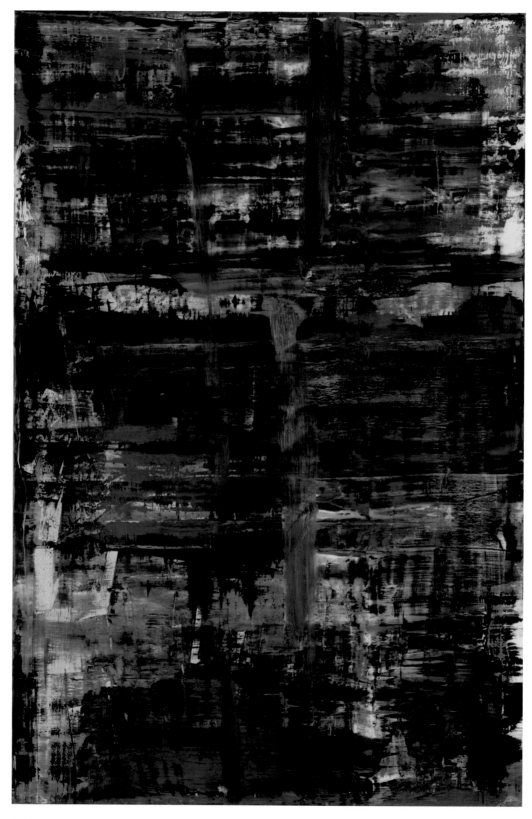

Wald (8)

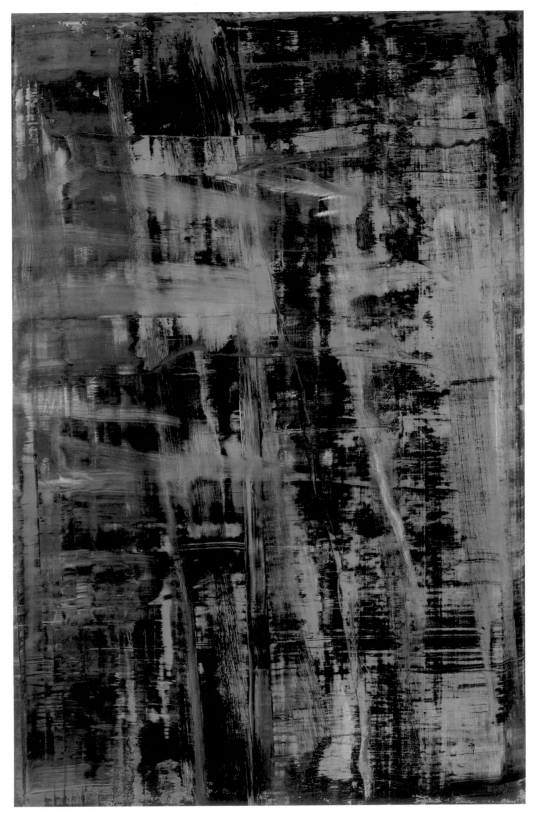

Wald (9)

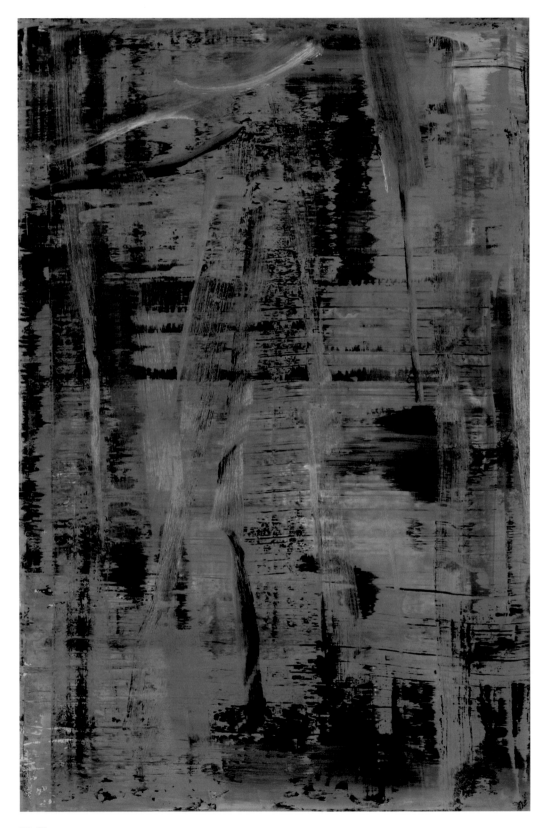

Wald (10)

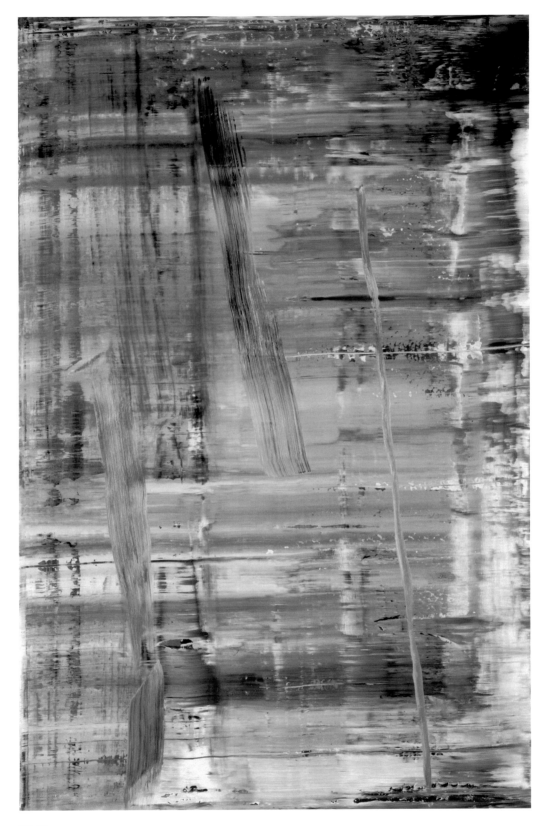

Wald (11)

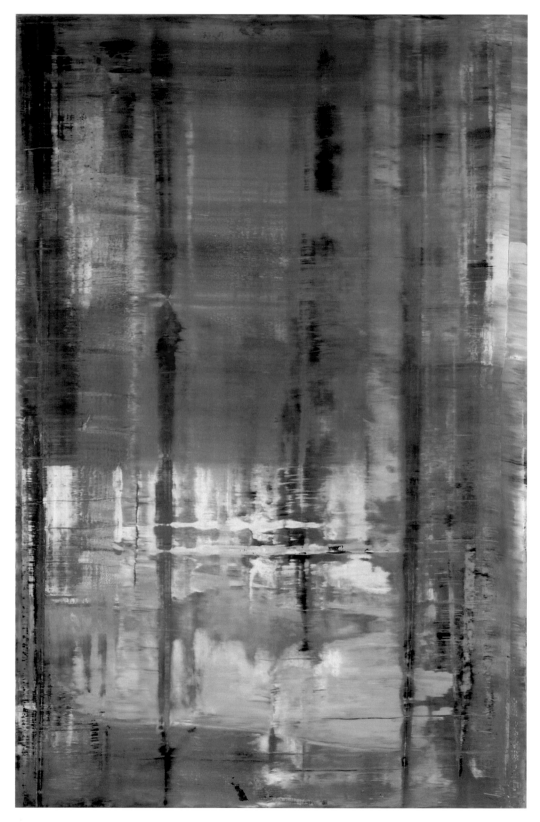

Wald (12)

JEANNE ANNE NUGENT

Interview with Gerhard Richter

May – June 2006

JN: *The Getty exhibition is an affirmation of a German tradition in painting, a very complex and, at times, troublesome history. With Caspar David Friedrich heavily represented at one end and you at the other, one might get the idea that you are the standard- bearer of painting for Germany. How might you feel about that?*

GR: Positively, although perhaps I'd prefer to say "trooper" rather than "standard-bearer," joining forces with those who feel an allegiance to tradition, and especially to a tradition that owes something to Friedrich. I'm very happy to be counted as part of that.

JN: *What does tradition mean to you? Was it always important for your work?*

GR: Tradition was simply a given, a valuable cultural heritage that set standards. Of course having an attitude like that put me outside the trend that thinks it fashionable to decry tradition, and to talk about the end of history and of art. You know more about it than I do.

JN: *Yes, the end of art and the death of painting have become commonplaces of art history. However in the 1960s, that stance wasn't all that alien to you, was it?*

GR: It's true that when you're young you tend to spout provocations, and if the time seems right for it, you come up with some pretty brash proposals, like sinking Venice or flattening the Alps. One shouldn't take all of that too seriously.

JN: *Your artistic career is closely connected with Dresden. You were born there, moved further east during the war, and returned in the 1950s to attend the Dresden Art Academy. Your earliest watercolors from the 1940s seem to have been influenced by Romantic landscape painting, and perhaps also by* Die Brücke *and* Der Blaue Reiter. *How did you first become aware of these artistic movements?*

GR: From books and from the little folios with art prints that you used to get then—I remember Diego Velázquez, Albrecht Dürer, Lovis Corinth—but that was before my time at the Dresden Art Academy. It was simply a matter of what was around, what we saw and bought for ourselves.

JN: *It's very important that it was in Dresden that you first became familiar with the great tradition of German painting.*

GR: Yes. My time in Dresden fundamentally and powerfully influenced me, although I wasn't really aware of it at the time. I realized it later. However, as far as the "great tradition of German painting" goes, I received a very patchy account of that due to the ideological slant on art as it was taught to us, and the attitudes about modern art that were more or less mangled by the time they reached us from the West.

JN: *Of course it's a problematic story, but you painted quite a bit and knew a lot about tradition nonetheless.*

GR: But the point is that I never tried to paint like Rembrandt or Raphael or Friedrich, I wouldn't have been able to paint like them anyway—I just wanted to see if I could capture that mysterious, lasting quality that so many of those old paintings have.

JN: *That's the thing I find so interesting about your work. It always has had a lot to do with history, German history, German art history, and the history of art more generally. Yet your work is modern, new, and one might say, mysterious.*

GR: Maybe a specific example could shed some light on that. The five paintings I did on Titian's *Annunciation*, you know the ones. When I saw Titian's painting in the Accademia I just wanted it for myself, for my apartment, so I decided to copy it as far as I could. But I couldn't even manage a semi-presentable copy. So then I painted five variations on the Annun-

ciation that didn't have much to do with Titian's *Annunciation* but that I was quite happy with.

JN: *Yes, but I must say that many of your works from the GDR have a similar effect, for instance* The Supper *with Adolf Menzel, Pablo Picasso, and Mona Lisa, and other works from that time were very—*

GR: —typical of my attitude? Yes—but the quality was really very poor, forgivable for a student maybe—

JN: *—no, they were clever, clever responses to tradition, in my view. I know* The Supper *wasn't a "great painting," but the idea that you were so young and could see that this problematic history had something comic about it was quite perspicacious. To put all those art historical figures together at a dinner table suggested to me your sense of what I would call the absurdity of a "cut-and-paste" tradition.*

GR: If you like.

JN: *What do you understand by tradition, especially in the sense of knowing a tradition well enough to break with it? And when that happens, what is it that gets broken?*

GR: The urge to break with a tradition is only appropriate when you're dealing with an outdated, troublesome tradition; I never really thought about that because I take the old-fashioned approach of equating tradition with value (which may be a failing). But whatever the case, positive tradition can also provoke opposition if it's too powerful, too overwhelming, too demanding. That would basically be about the human side of wanting to hold your own.

JN: *The value of those traditions also might be about time-lessness—*

GR: Yes, that is the most important effect of true quality, that it's as simple as it is mysterious, that it's just naturally there but completely incalculable. And it's not confined to a particular discipline or era: you can find it in Giotto, John Cage, Johann Sebastian Bach, or whomever else.

JN: *The experimental freedom of your adolescent work changed after you entered the Dresden Art Academy. On the one hand the formal training resulted in a number of accomplished figure drawings, still life paintings, and portraits. On the other hand socialist subject matter was introduced and you began to tackle complex multi-figure compositions*

with increasing confidence. Although it was a long time ago, perhaps you could comment on whether you had a sense that you were giving something up when you moved from the experimental watercolors to your academic training, or whether at first the new program seemed positive, a legitimate step forward towards a new art?*

GR: I did notice a loss of spontaneity and freedom, but I just accepted the training as necessary, unavoidable toil.

JN: *Could you say how much the nature of the training has influenced you since then?*

GR: Although it would seem totally outmoded today, this is the training I had, and even as a student I was convinced, and still am, that it was exactly right. The craft skills we learned developed a feeling for materials, and drawing and painting from life were invaluable for the development of the eye. The one-sidedness of the "do's and don'ts" could also be taken as positive because it encouraged one's capacity to resist and oppose. If we couldn't check books out, we just studied them all the more closely in the reading room, and the things that were absolutely forbidden became all the more exciting.

JN: *So which books and catalogues did you have access to in the Dresden Art Academy library?*

GR: Well, you could borrow anything up to Edouard Manet, but everything after that, from the Impressionists onwards, could only be consulted in the reading room.

JN: *I see, so they were there.*

GR: Yes, but not nearly so many as the classics and the closer you got to the present, the fewer there were. The only exceptions were contemporary artists who were card-carrying members of some Communist Party—like André Fougeron, Renato Guttuso, and the rest—you could borrow books about them. And the excuse we were given for their "formalism" was that they were forced to go along with western modernism in order to survive. Utter nonsense—which of course made it very easy for us to form our own opinions.

JN: *The daily schedule of classes at the Art Academy took up practically the entire day. How did you manage to experiment*

with any real freedom when you were faced with such ideological constraints?

GR: With a little vigilance you soon found the gaps in the barrage of rules, and of course, most importantly, you also had like-minded friends.

JN: *Artistic friendships always have been important to you, naturally beginning in East Germany. Many of your fellow students in Dresden who remained there throughout the Cold War—people like Wieland Förster, Wilfred Werz, and Helmut Heinze—became leading exponents of artistic trends within the GDR. They are all representational artists, but they all distanced themselves from the didactic art propagated by the state. It seems to me they were taking the same "third way" that you have talked about in connection with your own work when you were in the GDR. How did these friendships add to your education at the Art Academy?*

GR: They were part of it, probably the most important part of all.

JN: *And that's when the idea of the "third way" came up?*

GR: Yes, for sure.

JN: *A third way—wasn't that a bit idealistic?*

GR: Oh yes, the dream of an intact world—in the midst of so many political fronts.

JN: *And at first you, too, were idealistic about Socialism, weren't you?*

GR: No, never in fact. The ending "ism" was enough to make me immune to any susceptibility in that direction.

JN: *I see. I think it's astonishing that you got away with that attitude and painted such a great number of pictures in the GDR.*

GR: For a start, the GDR wasn't the same kind of dictatorship that prevailed in Nazi Germany, and it was possible to create your own space to some degree. And then, I just really relished painting—in fact, any kind of work—which can be a great help in all sorts of difficult situations.

JN: *So you found a way to cope with the system in the GDR and produced a lot of pictures that are both idealistic and*

technically well painted. Among the personal works there are some very accomplished family portraits, such as Die Leserin (Ema), *among others. These are positive images from the GDR, if I can put it like that. Despite everything you found the freedom to pick out the things that were worthwhile for you, so that you could develop there.*

GR: So it would seem.

JN: *The Leipzig painter Werner Tübke is one of the only artists in the Getty exhibition who also worked in the GDR. You left, but he stayed. He is almost unknown in the US, although the next generation of artists who studied with him and his colleagues Bernhard Heisig and Wolfgang Mattheuer at the Leipzig School has made its mark here in the US. Tübke's work sought to combine history painting with Socialist themes. Your work also engages with tradition, but its resistance to any kind of instrumentalization gives your pictures a completely different motivation. You seem to want to demonstrate resistance in your work, is that true?*

GR: I certainly did not want to demonstrate resistance because that would have meant countenancing that very instrumentalization. I just want to paint pictures.

JN: *I realize that you do not wish to be compared with Tübke—*

GR: —on the contrary, why not compare? But I've already talked about the difference when we were discussing the *Annunciation* pictures: Tübke wants to paint as wonderfully as the Old Masters, and he is unusually gifted at it; he's a great illustrator. I can't do that, and I don't want to either.

JN: *Of course. He's harking back to a tradition of sheer skill, but strictly speaking he always had a very narrow view of tradition, whereas your view is much wider. Is that just an East/West issue, or something else?*

GR: Actually, it has nothing to do with that—if it does at all, then it is only in the sense that Socialist Realism demanded precisely that kind of illustrative dexterity. In the West Tübke would have found completely different applications for his extraordinary talent.

JN: *The role of photography in your work has been much discussed over the years. When I was researching your early career in Dresden I was surprised to discover how much you used photography when you were still in the GDR. You didn't*

just turn to it as a tool when you were painting, or as a means to document your own work, you also photographed works of art that were banned by the state. Could you say a few words about the need for that?

GR: It's not that unusual—people are forever photographing things they can't take with them. So if I could only see a painting in the West, or only once in a catalogue, of course I would take a picture of it. But I also think I was probably more curious and impatient than most.

JN: *But I was really astonished when I found so many photographs of works of art that you took for your artist-friends, for instance the shots from a book about Henry Moore. You photographed the entire book! After I saw the photographs I realized that, yes, of course, you learned something else from those modernist genres and traditions, a different approach, wouldn't you say? And at the same time you took a lot of pictures of your own works, and the works of others in exhibitions and books in the West. Photography became a part of your particular "way of seeing," didn't it?*

GR: Could be. But whatever the case, this technology presented a wonderful chance to document something I had seen, and then to see it again as a small image. For me it's a way of constantly training my eye. And a way of appropriating things that comes more naturally to me than words.

JN: *In doing so you took a path that ran counter to the dominant ideology, because books on Henry Moore and Picasso were not officially available. It is unusual that you worked so intensively with the camera in those days, and then later, after you left, it's as though you reinvented your work through the camera.*

GR: By painting from photographs?

JN: *Yes. But in the GDR you used photography not just to preserve things but also to internalize them and visualize them. Is that right?*

GR: Sure. But for me this practice is so natural that I can't explain anything about it to you—I don't know anything about it.

JN: *Right, okay. But my question is about the early influences. Don't you think the social and historical circumstances of your education also influenced your very way of seeing?*

GR: Yes, of course I do. Naturally.

JN: *In the 1960s the contrast between art schools in East Germany and the Dusseldorf Art Academy hardly could have been greater. Many people don't realize how much you had experimented with* Informel *before you started on your first series of Photo-Paintings in the West. This is largely because you burned those abstract works when you were at the Dusseldorf Art Academy. You were rather skeptical about* Informel *in those days.*

GR: It's more that I was skeptical about my own attempts—

JN: *—yes, but later you revisited* Informel—

GR: —it's not that I had anything against *Informel* art, it was just that I couldn't be part of that, I had to find my own way—

JN: *And later in revisiting* Informel *you achieved a certain elegance in your work through painterly qualities, and perhaps, in spite of yourself.*

GR: I think I know what you mean—in the sciences and in mathematics there are elegant solutions, but in art elegance is a slightly derogatory word. I have no objection to either the one or the other kind of elegance.

JN: *Along with elegance and painterliness comes expression. Yet as a young man, you frequently spoke out against expressivity. Later it was: no, I want expressivity. Why?*

GR: It's true that I'm not really drawn to the so-called Expressionists, although it has little to do with the individual painters, some of whose pictures I might like a great deal. I just don't like the propaganda-style slogan, the label "Expressionism" that's attached to a certain crude brand of dilettantish painting.

JN: *But your work does have something to do with expressivity.*

GR: I should hope so! Pictures that don't express anything, that say nothing, would be completely uninteresting.

JN: *Let us turn now to your new paintings in the Getty exhibition: the twelve abstract paintings that make up the series entitled* Wald, *which might be translated as*

"forest," "woods," or "woodland." The title evokes a literal connection with the subject of many of Friedrich's paintings, but for me, the new abstract series come closer to Friedrich in mood and atmosphere, more so in fact than your earlier Friedrichesque landscapes based on photographs. Is this apparent to you? How might you explain that?

GR: That's too difficult for me; I'm bad at interpreting art. I can only confirm that you are right about the affinity to Friedrich, but I can't explain why. Whatever the case, I agree that these twelve abstract, intricate, scratchy paintings have much more to do with the spirit of Friedrich's paintings. Because of their superficial similarity to Friedrich, my smoothly painted landscapes [the earlier Photo-Paintings] are somewhat embarrassing in the connection to Friedrich. It's a very different relationship that comes through the two groups of my work.

JN: *Yes, and about fifteen or sixteen years ago you already used the title* Wald *for four large-format abstract paintings.*

GR: Yes. Those abstract paintings are more homogenous than the twelve new ones, and their predominant blue tone connects them more readily with Romanticism. The new work presents a different kind of "forest," if we want to take the title that literally, or it simply might be that I've gone further with the idea.

JN: *We're nearly finished, but I do have to ask—is there a "German spirit" in painting?*

GR: I believe so, yes. But I'd rather not know the details.

Author's note:
This text was compiled from a series of conversations in German between the author and the artist in May and June of 2006. For advice concerning the German-language framing of the questions, the author would like to thank Mechthild Fend, Martin Richter, and Christina Rosnersky.

Translated from the German by Fiona Elliott and Jeanne Nugent.

Bibliography

Andree, Rolf: *Arnold Böcklin. Die Gemälde*, Basel 1977 (Swiss Institute for Art Research, Œuvre Catalogues, Swiss Artists 6); second edition with a supplement by Hans Holenweg, Basel 1998.

Bang, Marie Lødrup: *Johan Christian Dahl 1788–1857. Life and Works*, Oslo 1987, 3 vols.

Baucamp, Eduard: *Werner Tübke*, exh.cat. Galerie Claude Bernard Paris, Paris 1995.

Beck, Rainer: *Otto Dix. Die kosmischen Bilder. Zwischen Sehnsucht und Schwangerem Weib*, Dresden 2003.

Berend-Corinth, Charlotte: *Lovis Corinth – Die Gemälde*, Werkverzeichnis, (neu bearb.) Béatrice Hernad, mit einer Einführung von Hans-Jürgen Imiela, Munich 1992 (2nd ed.).

Bischoff, Ulrich (ed.): *Galerie Neue Meister, Staatliche Kunstsammlungen Dresden*, Munich/Berlin 2003 (2nd ed.).

Bischoff, Ulrich and Gerd Spitzer (eds.): *Ludwig Richter – Der Maler*, exh.cat. Galerie Neue Meister, Staatliche Kunstsammlungen Dresden, Munich 2003.

Börsch-Supan, Helmut and Karl Wilhelm Jähnig: *Caspar David Friedrich. Gemälde, Druckgraphik und bildmäßige Zeichnungen*, Munich 1973.

Busch, Werner: *Caspar David Friedrich: Ästhetik und Religion*, Munich 2003.

Carus, Carl Gustav: *Lebenserinnerungen und Denkwürdigkeiten*, Leipzig 1865/66.

Czymmek, Götz and Christian Lenz (eds.): *Wilhelm Leibl zum 150. Geburtstag*, exh.cat. Neue Pinakothek Munich/Wallraff-Richartz-Museum Cologne, Heidelberg 1994.

Eberle, Mathias: *Max Liebermann 1847–1935. Werkverzeichnis der Gemälde und Ölstudien*, 2 vols., Munich 1995/96.

Friedrich, Karl Josef: *Die Gemälde Ludwig Richters*, Berlin 1937.

Gaßner, Hubertus (ed.): *Caspar David Friedrich: Die Erfindung der Romantik*, exh.cat. Museum Folkwang Essen/Hamburger Kunsthalle, Munich 2006.

Grohmann, Will: *Karl Schmidt-Rottluff*, Stuttgart 1956.

Guratzsch, Herwig (ed.): *Julius Schnorr von Carolsfeld 1794–1872*, exh.cat. Museum der Bildenden Künste Leipzig, Leipzig 1994.

Heilmann, Christoph: *Caspar David Friedrich*, exh.cat. Neue Pinakothek Munich 1984.

Hinz, Sigrid (ed.): *Caspar David Friedrich in Briefen und Bekenntnissen*, Berlin 1958.

Löffler, Fritz: *Otto Dix 1891–1969. Œuvre der Gemälde*, Recklinghausen 1981.

Lorenz, Ulrike (ed.): *Otto Dix. Welt und Sinnlichkeit*, exh.cat. Kunstforum Ostdeutsche Galerie Regensburg, Regensburg 2005.

Meißner, Günter (ed.): *Werner Tübke. Leben und Werk*, Leipzig 1989.

Möller, Heino R.: *Carl Blechen – Romantische Malerei und Ironie*, Weimar 1995.

Obrist, Hans-Ulrich (ed.): Text: *Gerhard Richter – Schriften und Interviews*, Frankfurt/M. 1993.

Prause, Marianne: *Carl Gustav Carus*, Berlin 1968.

Rave, Paul Ortwin: *Karl Blechen. Leben, Würdigungen, Werk*, Berlin 1940.

Schnorr von Carolsfeld, Julius: *Briefe aus Italien von Julius Schnorr von Carolsfeld, geschrieben in den Jahren 1817 bis 1827: Ein Beitrag zur Geschichte seines Lebens und der Kunstbetrachtungen seiner Zeit*, Gotha 1886.

Schuster, Peter-Klaus, Christoph Vitali and Barbara Butts (eds.): *Lovis Corinth*, exh.cat. Haus der Kunst Munich/Nationalgalerie im Alten Museum Berlin, Munich/New York 1996 (English edition, The Saint Louis Art Museum, Tate Gallery London 1996).

Spitzer, Gerd (ed.): *Christian Friedrich Gille 1805–1899*, exh.cat. Gemäldegalerie Neue Meister, Staatliche Kunstsammlungen Dresden/Kunsthalle Bremen, Leipzig 1994.

Staatliche Kunstsammlungen Dresden (ed.): *Gemäldegalerie Dresden – Neue Meister. 19. und 20. Jahrhundert. Bestandskatalog und Verzeichnis der beschlagnahmten, vernichteten und vermissten Gemälde*, Dresden 1987.

Teichmann, Michael: *Julius Schnorr von Carolsfeld (1794–1872) und seine Ölgemälde*, Monographie und Werkverzeichnis, Frankfurt/M. 2001.

Thiem, Gunther and Armin Zweite (eds.): *Karl Schmidt-Rottluff. Retrospektive*, exh.cat. Kunsthalle Bremen/Städtische Galerie im Lenbachhaus Munich, Munich 1989.

Tübke, Brigitte: *Werner Tübke – Das malerische Werk: Verzeichnis der Gemälde 1976 bis 1999*, exh.cat. Panorama-Museum Bad Frankenhausen, Dresden 1999.

Uhlitzsch, Joachim: "Zwei bedeutende Werke von Otto Dix der Gemäldegalerie Neue Meister gestiftet," in: *Dresdener Kunstblätter*, vol.16. (1972), issue 1, pp. 2–5.

Waldmann, Emil: *Wilhelm Leibl. Eine Darstellung seiner Kunst. Gesamtverzeichnis seiner Gemälde*, Berlin 1930 (2nd ed.).